The Gift of Calligraphy

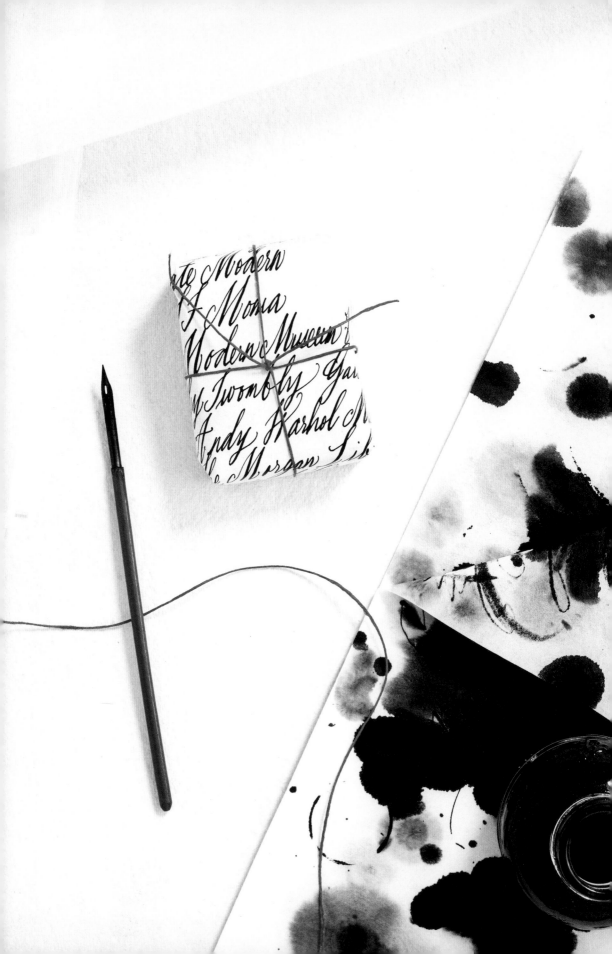

THE Gift OF Calligraphy

A MODERN APPROACH TO HAND LETTERING
WITH 25 PROJECTS TO GIVE & TO KEEP

MAYBELLE IMASA-STUKULS

FOREWORD **DARCY MILLER**
PHOTOGRAPHS **THUSS+FARRELL**

WATSON·GUPTILL
CALIFORNIA | NEW YORK

Copyright © 2018 by Maybelle Imasa-Stukuls
Photographs copyright © 2018 by Thuss + Farrell
All rights reserved.

Published in the United States by Watson-Guptill Publications, an imprint of the Crown Publishing Group,
a division of Penguin Random House LLC, New York.
www.crownpublishing.com
www.watsonguptill.com

Library of Congress Cataloging-in-Publication Data is on file with the publisher.

Hardcover ISBN: 978-0-399-57920-2
eBook ISBN: 978-0-399-57921-9

Printed in China

Art direction, book design, photography, styling / THUSS + FARRELL
Assistant Prop Styling / Poet Farrell

10 9 8 7 6 5 4 3 2 1

First Edition

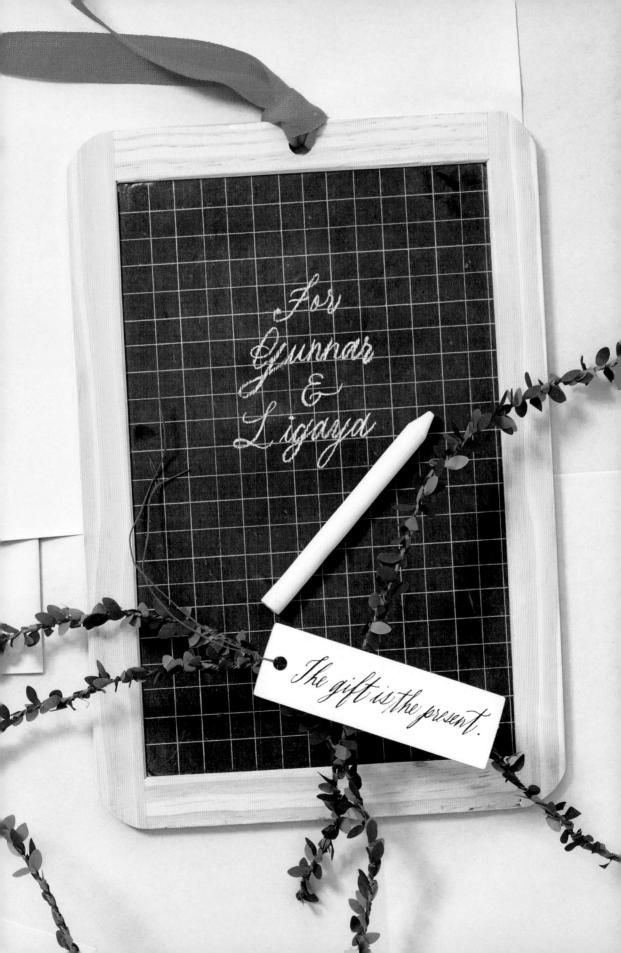

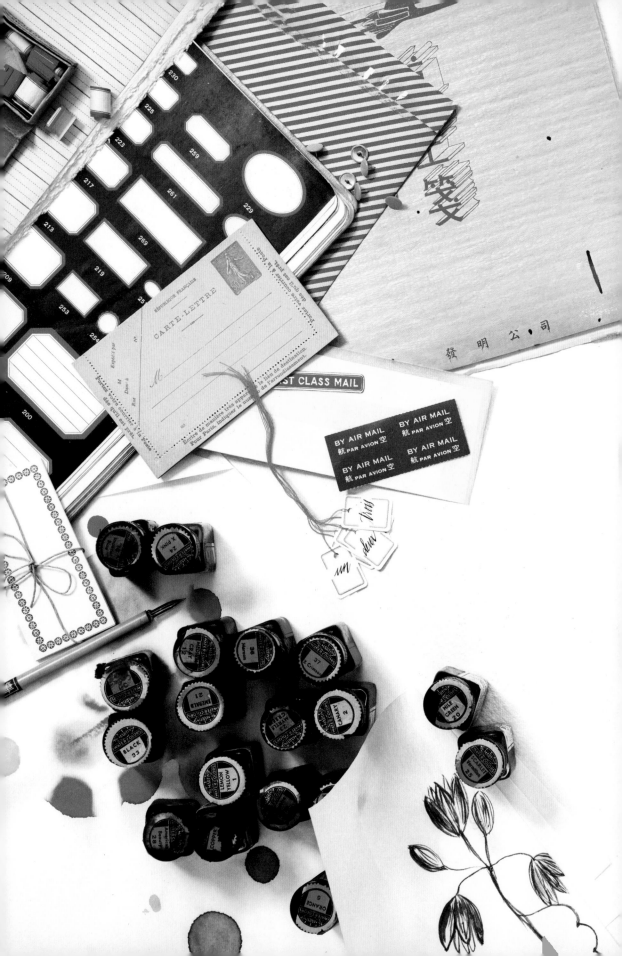

Contents

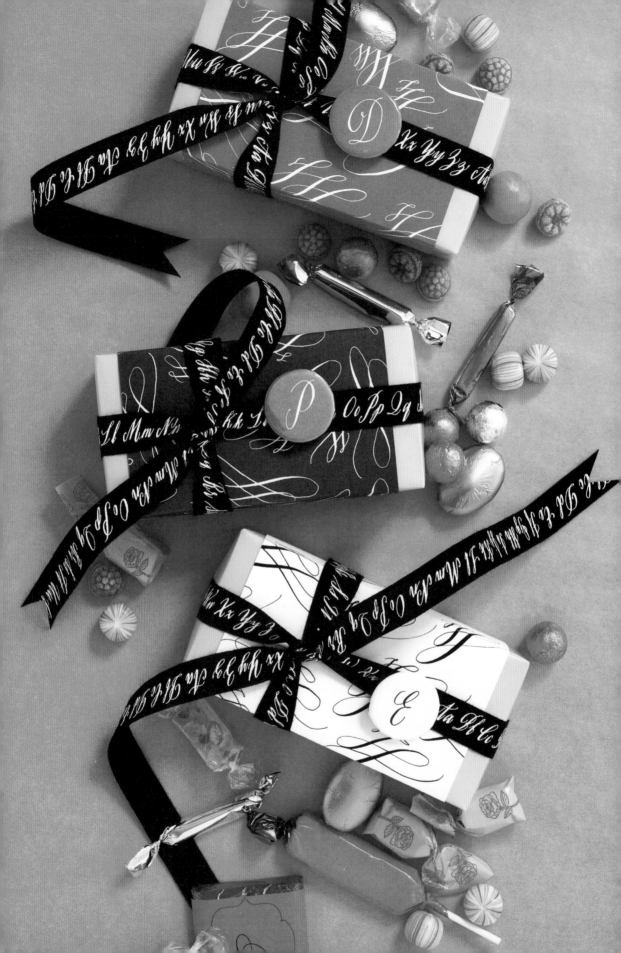

Foreword

I've worked with many calligraphers over the years and was beyond excited to find out that Maybelle was writing a book—and now you can see why! As a big fan of calligraphy, and a veteran of the wedding and party industry, I've always been drawn to Maybelle's ebullient style because of the joy her art exudes. I've been lucky to collaborate with her on several different projects and, every time, her work and her personality bring something special to the experience. There is true happiness in her calligraphy, and this book allows her to share that happiness with others.

I'll never forget the lazy Sunday morning Maybelle came to our home to give me, my mother, and my three daughters a calligraphy class. Her approach allows people to relax, spend time together, and just be present—which fits in with our family philosophy of "always DIT (Do It Together)." For hours we were swept up in her teaching, learning strokes, and letters, captivated by how easy and enjoyable she made calligraphy—it was pure fun with pens and paper.

Maybelle always says, "Learning is a gift to yourself." Learning calligraphy will give you a talent that you can then share with others; you'll be able to create personalized, custom works of art, whether you're writing placecards or love letters. Beautiful, helpful, and beyond inspiring, this book is a true gift to its readers—which is no surprise to me, given the talents of its author, as well as the talents of Rebecca and Patrick, its photographers and designers. I know it will be put to very good use in our home—and I look forward to sharing it with others!

Congratulations, Maybelle, and thank you for sharing your very special gift with us.

Darcy Miller

Editor, *Martha Stewart Weddings*

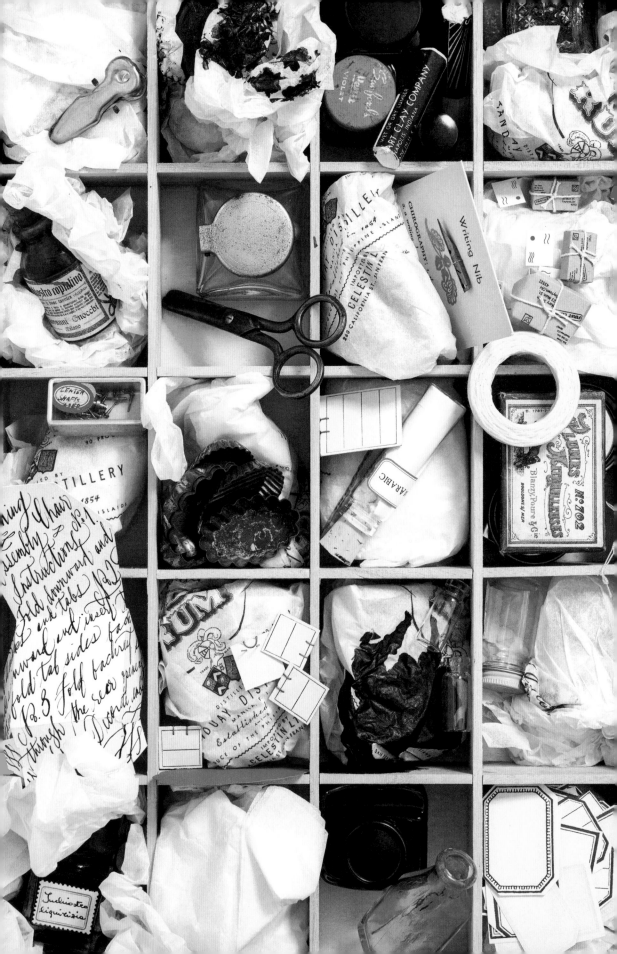

Introduction

I have a degree in graphic design, but I didn't take the usual path that most graduates follow by finding work in a design-, publishing-, or advertising-related field. Instead—quite by accident, actually—after I completed my Bachelor of Fine Arts degree I became a flight attendant! Through a serendipitous set of circumstances and introductions from friends, I ended up with a completely unexpected job that allowed me to travel the world extensively. As it turns out, having a flexible day job ended up being an ideal way to support my career as an artist. Even though I lived out of my suitcase, I always made sure to take my travel art studio with me. I used my supplies to send handwritten letters and pieces of handcrafted art from the exotic locations I visited to the many friends I made around the world. Wherever my plane landed, I made it a point to seek out special manuscript collections and art exhibits at museums. If I was in a city I'd never been to before, I would forgo the normal tourist spots and head to places like flea markets and local grocery stores to observe, sketch, and collect. Over time I accumulated many pieces of ephemera—vintage labels, notebooks, letters—from all over the globe. Seeing the world fed my creativity.

On September 11, 2001, I was in the air as a working crew member on a flight home to San Francisco from Frankfurt, Germany, when the terrorist attacks occurred. With the immediate decline of the travel industry, I was laid off from my job. Events like this shift your perspective and can be life changing, so I took some time to really think about the kind of work that would make me truly happy. I was at a complete loss for what would come next. It was then that I started taking calligraphy lessons—a gift from my husband, Greg. Trust me when I say that as a beginner, I wasn't very good. At that point most people would have just quit and moved on to something else, but I found that once I let go of the idea that my letterforms had to be "perfect," I felt a weight was lifted and everything started to flow. Calligraphy turned out to be

Some of my most treasured objects kept in an old wooden divided box.

very enjoyable and meditative, and made me feel centered. The more I practiced, the more I embraced calligraphy as another form of artistic expression—and I loved it.

At the same time, I noticed that everyone around me seemed to be getting married. What a perfect way to use my newly acquired skills and give a meaningful gift by designing invitations and hand-addressing the envelopes! Eventually I had created enough invitation designs to put together a portfolio, and on a whim I mailed it to the editors at *Martha Stewart Weddings* magazine. This was the time before blogs and social media existed as a way for artists to connect with potential clients. I didn't hear anything back right away, so I followed up with a letter written in my best amateur calligraphy. Just days later an editor responded and commissioned me to create work for her very own wedding! That event was featured in a ten-page story in the magazine . . . and suddenly my calligraphy was in demand.

I never would have imagined that more than a decade later my work would be regularly featured in the magazine as well as on a wide variety of wedding blogs. With the confidence and skills I gained from these private and commercial commissions, I grew my hobby into a real business. I have taught calligraphy workshops around the world, filmed an online video class for Creativebug, published a calligraphy kit with Chronicle Books, and designed products for national retailers.

Over the years, friends often asked when I would write my own book about calligraphy. And then my publisher, Watson-Guptill, approached me and suggested I write "the dream book that you have always wanted to write." I had many family and work obligations and I didn't think I had the time to actually sit down and write an entire book. Lucky for me, my friends Rebecca Thuss and Patrick Farrell came to visit the Bay Area and, over lunch when I mentioned the possibility of writing this "dream book," they said they would love to style and shoot the photographs for it. Almost instantly I had a clear vision of how to organize the book—it made perfect sense and felt like something I could really accomplish. I had met Rebecca when I was just starting in my professional career as a calligrapher, and we developed a great working relationship. To collaborate with her on this book was a huge honor.

Unfortunately the universe works in strange ways sometimes, and on the very day I was offered a book contract, I was diagnosed with early stage breast cancer. As it turns out, calligraphy and the writing of this book became a crucial part of my coping and healing processes. The work has been a beautiful

distraction and is one of reasons I was able to remain positive during my treatments. I realized, too, how an art practice can impact your life in such profound ways. During the six months that I received weekly chemotherapy treatments, I experienced neuropathy, a side effect that causes tingling and numbness in your fingers. The worst part of it was that I couldn't even hold a pen. Thankfully the neuropathy was temporary. Yet the threat of never being able to use my hands again made me realize how much I needed to share my love for this art form. I now know that calligraphy is an extension of my soul, and gives my life purpose and meaning. My daily practice allows me to make time for myself to do something creative—even if it's quickly writing out a shopping list. My style is still not "perfect," no two letters are exactly alike, and it's quirky. I have embraced this imperfection and learned how to let go of the outcome.

Whether you are just starting out with calligraphy or have some experience already, I hope you will find this book a source of inspiration and a guide to help create your own practice and style. The projects in this book range from easy to advanced, and I created them with the idea of making and giving something handcrafted. I hope you will find that the act of making a gift to give is also an invaluable gift to yourself. Take pride in the fact that you created the gift by hand—and let go of the idea of perfection. If you are patient with yourself and remember to have fun, you will discover the many ways that the gift of calligraphy can spread love and kindness in unexpected places.

May

On the bottom right, amid some of my favorite items that I have created, is a wooden box that I mailed to Rebecca when she was working at *Martha Stewart Weddings*. I was delighted to see that she still has it after all these years!

Practice patience. Smile often. Savor special moments Make new friends, Rediscover old ones Tell those you love that you do. Fe deeply. Forget trouble. Forgive a nemy. Hope. Grow. Be crazy. Co your blessings. Observe miracles. Make them happen. Discard wor Give. Give in. Keep a promise. Look for rainbows. Gaze at sta See beauty everywhere. Work h Be wise. Try to understand. Take ti o people. Make time for yourself. Lis

Modern Calligraphy & Inspiration

Some vintage examples from my personal collection of different types of calligraphy. I've collected (and continue to collect!) all manner of calligraphic works that I find at thrift stores, flea markets, eBay, and Etsy, both at home and abroad.

What Is Calligraphy?

The word *calligraphy* is a broad term that encompasses many writing styles from different parts of the world. Some forms of calligraphy are created using a brush dipped into ink. Others use a pen with a metal nib that may be chiseled, as in European and medieval styles, or pointed, in Spencerian and Copperplate styles for italics. The actual definition of the word *calligraphy* comes from the Greek word *kalligraphia*, which means "beautiful writing."

For thousands of years, writing has been the way information was passed on from generation to generation. Carefully drawing letterforms with precision and legibility was viewed as an art form, and these shapes were often quite ornamental and used in engravings. Even up until the end of the twentieth century, tidy handwriting—particularly cursive—was an integral part of schoolwork. Students were given "copybooks" and instructed to write their letterforms exactly as shown. Teachers would deduct points if their students' penmanship was "untidy," and students were strictly graded based on legibility. With the advent of computers and other technology, the importance of handwriting has declined, and many schools are dropping it as part of their curriculum. Perhaps because of this, calligraphy has become highly specialized and sought after for wedding materials, certificates, and paraphernalia for other special events.

Modern Calligraphy

The term *modern calligraphy* simply means that the style is derived from your own handwriting, and it usually describes work created after the year 2000. It was then that calligraphy's renaissance as an art form began, and there has been a huge increase in artists who use it in their work. It really is an exciting time to be a calligrapher, and to witness how artists use technology to quickly learn via YouTube or Instagram, and to reach a large audience on the Internet. Modern calligraphy is the best way to describe my work—and though my style is derived from many traditional styles, if you were to look at my actual handwriting, it does appear to be quite similar.

For those who practice calligraphy as a form of art, there is a wide range of skill levels, from hobbyists to professionals—and then there are a few who take it to the highest level and become Master Penmen. In the United States, becoming a Master requires a strict lettering process, and there are specific rules to follow established by the International Association for Master

Penmen, Engrossers, and Teachers of Handwriting (IAMPETH). In order to receive the official certificate as a Master, you must meet the IAMPETH's specific standards of the fine art of penmanship. Master Penman is the only official title available in the calligraphy world, but it's really more for those who are interested in creating historically accurate forms of calligraphy, as opposed to the modern calligraphy that I share in this book. While I have the utmost respect for traditional calligraphic styles, I do not consider myself a master. I believe one can be an exceptional calligrapher without technically being a master. It's like playing the piano—you don't need to be a professional concert pianist to enjoy it and share it with others.

Handwriting vs. Calligraphy

In my experience, people often have different perceptions about what calligraphy is. Some visualize an image of italic letters, which are forms written with a chiseled nib or felt-tip pen. Others think calligraphy is perfectly formed script with ornate letters and flourishes—in other words, just a fancier form of handwriting.

But what technically distinguishes calligraphy from handwriting is, with calligraphy, you are always dipping a brush or pen into ink. When you examine calligraphy from China, Korea, and Japan, the characters are artfully produced using a brush dipped into ink. Arabic script calligraphy is written with a carved reed pen dipped into ink. In this book you'll mostly learn about dipping a pointed metal nib into ink, though I'll also touch on other materials to experiment with.

Calligraphy also has a specific set of rules—such as the order in which you make strokes to form letters, how your letters connect to form words, the angle at which you hold your pen, and the amount of pressure you apply—that are stricter than the rules of handwriting. The rules of calligraphy also change, depending on the script being written. These specialized forms of writing have a distinct cultural and artistic significance beyond what we know as everyday handwriting.

While it is true that handwriting can be beautiful, it is usually created using a pencil or a pen with an ink cartridge (no dipping), for convenience. The primary purpose in handwriting is to convey a message—considering beauty is not typically part of the process. Calligraphy is created at a much slower pace, and the aesthetics of the letterforms are just as important as the content. Calligraphy takes its time.

The Beauty of Being a Beginner

Have you ever watched children create art? I love to observe my eight-year-old twins drawing, painting, or practicing their cursive handwriting (they are lucky to attend a school that still teaches cursive). They are curious and dive right in without having a voice in their heads that tells them they can't. I keep paper and pencils in my purse at all times to keep them entertained in the car or at restaurants, and I try to encourage them to use their imaginations as much as possible. Nothing makes me happier than to have them alongside me in my studio, and they are my biggest source of inspiration. I also volunteer regularly in their classroom to help familiarize other children with this disappearing art form, and I hope to spark new interest for all things written by hand. What I have observed by doing this is that most children are unafraid of making mistakes—and we adults could learn a lot from them.

Trying anything new can be daunting. If you can channel your inner child, you will forget about doing anything the wrong way. There is no wrong way, I promise. Adults are often too hard on themselves, or are so focused on the idea of a "perfect" outcome that they talk themselves out of even starting at all—particularly when it comes to learning something new like calligraphy or another art form. In this age of social media and instant gratification, the pressure is stronger than ever to be good at something right away. It's natural to compare your work to that of others, but remember that everyone learns at their own pace. Use where you started as a base to measure your own progress. Your beginning work should look like beginner work. Take a look at mine! To be honest, I relish my days as a beginner. I have easily put in 10,000 hours of practice, and yet when I feel my calligraphy is looking *too* perfect, I wish I could go back to those early days of uncertain, quirky lines. With so many years of practice under my belt, the idea of having "perfect" work sometimes gets in the way of my unhindered beginner's work.

THIS SPREAD A selection of items that I have collected during my travels as well as lists I've written of some of my favorite things.

PREVIOUS SPREAD Some of my first attempts with pointed pen along with examples written by my children with quills we made.

What Inspires Me

Everyone finds inspiration in their own way. Whenever I am asked about what inspires me, my answer changes depending on what I am interested in at the time. To say that everything around me is inspiring is somewhat true but it's way too general. When I dig deeper, I find that I am most inspired when I spend time in nature—I'm forced to slow down and be at one with my surroundings. After a stroll in the woods, my mind is cleared of the everyday clutter inside. In fact, in Japan the practice of taking a short leisurely stroll in nature is called *shinrin-yoku*, "forest bathing," and it has been proven that there are many health benefits to spending lots of time like this.

To keep my work feeling fresh, I try to stay away from researching projects online. There is too much information on the internet and I'd rather find my inspiration in less obvious places. I read magazines about art and anything art related, like interior design, food, fashion, and architecture. I have arranged to view special manuscript collections at private research libraries or museums. At the library I'll pick one topic (botany, for example) and head to that section to peruse the shelves. Sometimes I will discover a book that leads me down a rabbit hole of exploration. Even some encyclopedias, like the French Diderot editions, include calligraphy on the plates identifying botanicals. When you are looking for it, you'll see calligraphy or calligraphy-inspired motifs everywhere.

Next, I am constantly observing. I wander in stationery stores, kitchen and restaurant supply stores, scientific and medical supply shops, flea markets, and five-and-dime stores—the older the better. Actually, I view shops as museums: the way products are merchandised in an artful manner is like a gallery to me. And I am obsessed with packaging. If I'm at a grocery store, especially in foreign countries, I meander down the aisles looking at the packages of tea, chocolate, jam. Each country has its own unique approach to typography, illustration, packaging materials, and graphic design.

Always observe the world around you, ask yourself questions, and challenge yourself. What makes you *you*? What is your story? Look at your past work and reinvent it. Never tell yourself that you are not creative. The very fact that you are here reading this book means that you are creative! Look for things that inspire you, and before you know it, the sum of those parts—the textures, colors, patterns, and general vibe of the things you're drawn to—will start to help you define your own unique creative vision.

21-21 Design Sight
Isabella Stewart Gardner
The Metropolitan Museum of Art
Isamu Noguchi Garden Museum
Tate Modern
San Francisco Moma
Cy Twombly Gallery
Andy Warhol Museum
The Morgan Library
Musée d'Orsay
Victoria & Albert Museum

Calligraphers Who Inspire Me

There are a few calligraphers working today who are known for their distinct, modern styles. All of them take an artistic approach to calligraphy, as opposed to following traditional technique. I love what they are doing and I hope they will inspire you, too. On this page I have arranged a few samples of their artistry, and I encourage you to seek out more of their work online.

THIS PAGE Janis Anzalone is based in the San Francisco Bay Area; her styles are delicate and fluid. Australia-based Sabine Pick has a wonderful, free gestural style. The fun work featured here by Stephanie Fishwick, based in Charlotesville, Virginia, is just a snippet of the many styles she is capable of.

OPPOSITE Emily J. Snyder of Los Angeles creates wildly energetic work. Artist Lauren McIntosh, co-owner of Tail of the Yak, a boutique in Berkeley, California, was my first calligraphy teacher. My husband gifted me calligraphy lessons with her many moons ago. I cherish each treasure that I find at her shop, including the mapping pen that I first learned with.

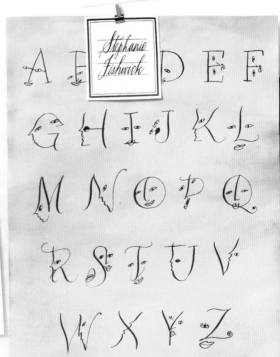

Emily J. Snyder

Lauren Mantooth

Forever Yours

You are gifted

"The meaning of life is to find your gift. The purpose of life is to give it away." This quote by Pablo Picasso has always resonated with me. I relish the moments when I first discovered calligraphy and would stay up until the wee hours of the morning practicing words and phrases. I felt myself connecting to the concept of finding my own gifts. Flash-forward to the present time and it all makes sense to me as I have discovered in the process of writing this book.

Remember that you, too, are gifted in so many ways. By trying something new you will discover unique talents within yourself.

Getting Started

Mindset

Calligraphy cannot be rushed. It is an art form that requires calm and focus. Your mind should be clear and you must give your full attention to what you are about to do. For your work to flow, it is just as important to have mind-body balance as it is for the pen, ink, and paper to be in harmony. Keep this in mind as you work through this chapter, which introduces you to the other essential elements of learning calligraphy: your work space, your tools, and the perfectly imperfect technique of putting pen to paper.

Work Space

While it is nice to have a designated work space, you don't need one in order to practice calligraphy. You can practice right on your kitchen or dining table as long as you have a comfortable chair. If your table is distressed or has an uneven surface, you may want to use a pad of paper or board to create a smooth surface. Be sure to protect the surface that you are working on (and the floor below) in case of any spills—black ink is not easy to clean and will stain.

I like to work in natural light whenever possible, so my desk is placed near a window. But I also like to use a light table for projects when I need guidelines but don't want to make pencil marks on the final piece. Newer light tables are not as bulky as the older models, so they can fit into most spaces. In my studio I have a large glass table that I turned into a light table by clamping a lamp to one of the legs. This allows me to work on pieces that are larger than the standard size of a light table.

Surrounding myself with objects, drawings, and collections from my travels constantly inspires me.

Tools

When you are first starting out with calligraphy, it isn't necessary to spend a lot of money on loads of supplies. I have found that all you really need to have on hand are the right type of pen, ink, and paper combination. My set of supplies includes many vintage things I've gathered over the years, but I'm always sure to keep the basics within arm's reach. Here's a list of essential things that I keep in my work space; see Sources (page 210) for where to purchase some items.

1 Straight nib holder and mapping pen Use a straight nib holder for holding the nib; I prefer wood over plastic. A mapping pen is used for tiny details and has a tubular shaped nib; I prefer Brause.

2 Nibs Pointed nibs such as Nikko G.

3 Brushes An assortment of natural or synthetic paintbrushes.

4 Container for distilled water For diluting white ink and mixing custom colors.

5 Jars Have a collection of small glass jars with lids for mixing colors. Jam or baby food jars work well.

6 Palettes Porcelain trays with separated wells for mixing ink or watercolors.

7 Pipette A small dropper for transferring ink from a bottle to a jar.

8 Ink I have a collection, but I use black sumi ink most of the time.

9 Cleaning rag and paper towels Used for cleaning ink off of your nibs.

10 Assorted paper and envelopes A stack of practice paper, plus a collection of textures and colors such as glassine, onionskin, black paper, and drawing paper made for use with pen and ink.

11 Vintage labels and tags I like to have a variety of unique things to work with.

12 Ruler For making guidelines; ideally at least 12 inches long.

13 Pencils and erasers Keep a selection of light and dark marking pencils. For lighter marks, I like to use mechanical pencils; for darker, I prefer Blackwing Pearl. Have a black eraser for use on dark papers and a white one for white and light papers, so they don't mark up your work. A kneaded eraser is great for erasing in tight spaces.

14 X-Acto knife and cutting mat Knife for cutting and mat to protect your work surface.

15 Bone folder For creasing and scoring card stock.

16 Light table For tracing and seeing guidelines underneath your papers.

17 Scissors Have a pair designated for cutting paper.

Pens

In calligraphy, the pen—which refers to a nib holder attached to a nib—is dipped into ink. By contrast, a fountain pen, with its own attached ink cartridge, is convenient and lovely, but it doesn't allow for the same amount of flexibility as a pointed calligraphy pen. The instrument used in the calligraphy that I create in this book is a wooden nib holder and a pointed steel nib that is dipped into ink. You will develop a preference for which type of pen you like to use. The following sections describe some of your options for nibs and holders.

FOR THOSE WHO ARE LEFT-HANDED

For the projects in this book, a straight nib holder will work fine for you if you are left-handed. The trickiest part will be finding the right position so your hand doesn't smear the ink. This may mean that the way you hold a calligraphy pen will be different then the way you grip a regular pen or pencil.

Tip

Slit

Side Slit

Vent Hole

Imprint Area

Shank

Nib Holder

Nibs

The calligraphy in this book is called *pointed pen calligraphy*, as we will be using a nib with a pointed tip that is inserted into a nib holder and dipped into ink. Nibs are usually made of metal, such as stainless steel, and are available in a range of different sizes and levels of flexibility or stiffness. Depending on which type of nib you are using, you can create variations of thick and thin lines by applying pressure.

Some nibs have more flex than others, and depending on how you hold your pen, different nibs will suit your particular hand. I encourage you to experiment. In the beginning you should try to find a nib that is easy to work with, lest you get frustrated and give up. Your nib should be sturdy but with enough flex to create thick and thin lines, and it should come back into its original pointed shape when you stop writing. If the nib picks up too many paper fibers or continues to give you lines that appear shaky, you'll want to find another nib to work with. My preferred nib for beginners is the made-in-Japan Nikko G nib, which happens to be popular with manga (Japanese comics) artists.

Small nibs, sometimes known as mapping pens, create finer details such as some strokes found on old maps. You can use broad-edge nibs for creating italics or blocky, thick letters without much variation of thick and thin. These broad-edge nibs will not work for the pointed pen style in this book, though, as they tend to be quite stiff and don't allow the flex that pointed nibs have.

You can find standard metal pointed-tip nibs at your local art or craft store. For more specific types, you'll need to go online or to a shop that specializes in calligraphy supplies. Brand-new nibs will sometimes have a coating or oily residue; clean the nib with a soft cloth before you use it. Some artists like to pass the nib over a flame or boil it before using, though I use them straight out of the box and have never experienced any problems. And of course, if you should be so lucky as to find a box of vintage nibs at a flea market or thrift store, you should definitely buy it and experiment with them! If you fall in love with vintage nibs, treasure and enjoy them! Once they are all used up they can be hard to find again—always be on the look out for more.

Nib Holders

Nib holders secure the metal nib and are about as long as a standard pen or pencil and generally are made of wood or, less commonly, plastic. Some have a cork or silicone cushion to make it comfortable to grip. No matter the style, the most important thing to look for in a nib holder is that it should hold your preferred nib in place without wiggling.

Nib holders usually have a round slot at the wider portion of the holder to accommodate the curve on the back end of most nibs. In most cases, a metal insert with prongs secures the nib. There are different types, but the most common insert with wooden holders is a metal ring with petal-shaped prongs inside the rim, which is inserted into the wooden shaft. The metal insert inside the holder is designed so that you can replace the nib easily. While in use, you may not realize that ink and water are getting caught in the slot, causing the nib to become permanently stuck inside. If this happens to you, gently remove the nib from the holder with a pair of needlenose pliers.

Oblique Nib Holder

An oblique nib holder is commonly used to create flourishes. The oblique holder positions the nib at a sharp angle that's hard for your hand to bend into if trying to use a regular pen. Once you get the hang of how to create a line using a straight holder and nib, you can start to experiment with the oblique holder and create your own style of flourishes.

A NOTE ON SAFETY

Take care when storing your holder when the nib is inserted. The safest way to store it is flat. Some people store holders like paintbrushes, with the tips pointing up. This is fine but be careful when reaching over them: if stored improperly, pointed nibs can be dangerous. If a nib is dipped into ink and you accidentally puncture your skin, you may get a mark that is very hard to remove—like an inadvertent tattoo.

A NOTE ABOUT NIBS

Keep a few nib holders on hand so that if you decide to use another type of nib, you don't need to keep changing them out.

Brushes

There are so many topics to cover when it comes to brush calligraphy, to teach it would fill an entire book. For our purposes, I advise you to keep a range of brushes on hand as you start to set up your work space. I stock an assortment—especially vintage or used brushes that are unusual—in my studio for times when I feel like making a beautiful mess. I prefer tapered brushes, such as round watercolor brushes. I like the lines of very delicate small brushes, such as shader, liner, and detailer brushes; I am able to achieve a similar look with these types as when I write with a pen.

For brush work you can use the same inks you would use for pointed pen calligraphy. Brush pens that contain a cartridge of black ink in the body of the pen and a brush tip protected with a cap, such as Pentel pocket brush and Kuretake brush pens, are easy to find online and handy when you don't want to open a bottle of ink.

Paper for Practice

The best kind of paper to use when you are just starting out and for practice would be anything that is smooth and readily available. Look for something fairly inexpensive such as bond paper or paper for laser printers (not ink-jet printers), easily found in reams (usually 500 sheets) at office supply or commercial paper stores. Sometimes these stores will sell sample sheets for a nominal fee. Take advantage of this and test a paper before buying an entire ream, because it's not just about finding the right paper—it's about finding the right combination of paper, nib, and ink.

Paper comes in different weights, the two most common being *text*, which is a lighter weight used for everyday copies, and *card stock*, which is thicker and used for making greeting cards. If you plan to practice on paper over a lined guide sheet, look for a thin transparent paper such as vellum, also sold in reams (usually 500 sheets). Paper vellum is made of synthetic plant material and available in the thinnest weight (17 lb). Traditional vellum is handmade from prepared animal skin, which is also a smooth surface to write on, and is much more expensive than the synthetic kind—historical documents such as the Magna Carta were written on this type of vellum—so save it for special projects.

For practicing with a pointed pen, it's also best to avoid any handmade paper or anything made with excess pulp, such as a brown kraft paper. The fibers will catch on your nib, which can be frustrating, especially for beginners. Textured and hand-made papers are a good choice for pointed brush calligraphy.

At most fine art stores, papers are categorized depending on the intended use. Any smooth paper that indicates that it is suitable for pen and ink should work great for calligraphy. Paper made for printmaking, watercolor, drawing, and charcoal will work well too, and you may find some made specifically for calligraphy. Larger sizes are available for purchase by the sheet, and smaller sizes are available in pads of 20 sheets or so—but pads can be expensive, so may not be economical for practice. Some brands to look for are Clairefontaine and Rhodia. Eventually you will find the kind of paper that you like to work with through trial and error, and if you are open to experimenting with anything and everything, you're bound to discover something that you love.

Paper for Original Artwork

When creating work that you want to display as an original, it's a good idea to do your work on archival (acid free) paper. This means that the chemicals used to create the paper will not make it deteriorate over time; it will last and possibly be passed on to future generations. I have found that archival paper is much nicer paper to work on—but you will need to do a little bit of trial and error to be sure your ink, pen, and paper work in harmony. Visit your art store's paper department and explain that you are looking for archival-quality paper intended for pointed pen and ink.

A few of my favorite papers: Fabriano Medioevalis, smooth black, colored handmade, onionskin, glassine, vellum, Strathmore Drawing, and assorted vintage papers.

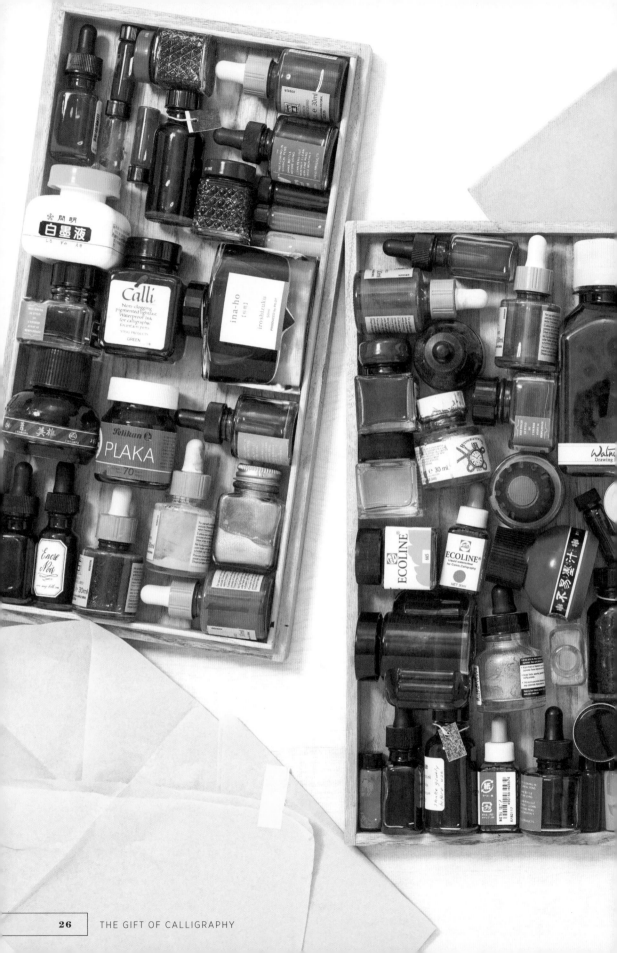

THE GIFT OF CALLIGRAPHY

Ink

I love to experiment with different inks. But to keep things simple in the beginning, start out by trying a basic black ink. Higgins, a thick permanent black ink, is easy to find at most art stores. One of my personal favorites, though not as readily available at art stores, is sumi ink (Moon Palace is my go-to favorite brand). It has a thicker consistency than basic black inks, but it allows for a nice flow with my favorite Nikko G nib. Sumi ink may sound familiar to you because it's the same formula that is used in Japanese and Chinese brush calligraphy.

Premixed inks are conveniently available in bottles. The packaging will indicate if the ink is suitable for use with pointed pens or a different kind of pen. Some inks are formulated for use with fountain pens. These tend to be thinner because they need to flow through the fountain pen's mechanism, and that consistency may not work so well with pens that are dipped in ink. If you are purchasing ink from a calligraphy supply store, they can help guide you to the right ones.

In the process of seeking out varied and vintage supplies, I have accumulated many bottles of ink. I have experimented with different types that are available at fine art and specialty stores as well. I would encourage you to experiment, too—you may discover unintended results that you quite like. (Keep in mind that while an ink may work well with your nib, changing the paper may create different results.) A few specialty inks you might seek out are iron gall, which looks transparent at first and then darkens as it dries, and walnut ink, which is made from walnut hulls and has a light to rich dark-brown color. See "Natural Colored Inks" on page 67 for more ideas.

I've been collecting inks for years. One of my favorites is this vintage 10-inch tall bottle of Pelikan ink gifted to me by my friend Phil. Other inks shown opposite: Walnut Drawing Ink, Sumi ink, metallic inks, acrylic, and fountain pen ink.

Pen Cleaners

When you are done using a pen or are taking a break, you must remember to clean the nib. Dried ink will clog the pen and cause the nib to create blots and trouble for you. To clean ink that has dried on your nib, simply dip the nib into pen cleaner or alcohol and wipe it with a soft rag or paper towel. If the ink has not dried on the nib yet, simply clean it with water and wipe it dry with a soft cloth. I prefer to use a rag made from soft linen or an old T-shirt. Paper towels are okay to use but be wary of the fibers in them. They are hard to see but sometimes they can get stuck in the nib, and then you'll see these fibers show up in your writing as a smudge—or if you are lucky, a happy accident like an artfully (but unintentionally) filled-in o.

Be extra careful not to submerge your wooden straight nib holders. Leaving anything wooden to sit in water could warp or crack it. Water could also cause your nib to rust and possibly get stuck in the holder permanently. If this happens, you may need a tool such as a long-nose plier to remove the nib from the holder.

Copybooks

A calligraphy copybook has printed letters for you to imitate— quite simply, a place to copy a sample alphabet. Begin your practice simply by looking at the letterforms, studying their shapes, spacing, patterns, and angles. Then pick up your pen. Some copybooks have a numbered sequence of strokes to follow, while others have an arrow simply guiding you in the right direction. All are great for learning and practicing, and you can reference them when you are trying out a new style. They're also great for warm-ups to kick-start your hand's muscle memory before beginning a project.

I also recommend getting a few vintage copybooks, as they are a great visual reference. You can find these at thrift stores, used bookstores, and antique markets, and on eBay.

Containers

Isn't it nice to have everything in its right place? I find it satisfying and convenient to organize my supplies in containers, which also help protect delicate glass ink bottles. I love old boxes of any kind, especially wooden ones. I scour flea markets all over the world looking for vintage cigar or art boxes. As you start collecting supplies you will eventually want to keep them all together in one place. For a long time I used our dining table as my practice space, so my wooden box came in handy as a place to put away all my

tools when I was done. Look for something small, such as a mints tin, to corral your tiny nibs. And if you'd like to do calligraphy when you are away from home, a sturdy box allows you to transport your supplies easily without damaging them.

Guide Sheets

I have included a guide sheet in the back of this book (page 197) for you to photocopy and use for your practice. It has angles that are meant to keep your letters more or less straight. But remember, this is just a general guideline. I tend to go outside the lines, and it's okay for you to, too. No two letters will be exactly alike, no two lines perfectly straight. I find that my writing tends to naturally lilt downward across the course of a line. When I want to keep my lines straighter, I use a guide sheet to keep myself on track. Photocopy the one in this book and then lay a sheet of vellum paper over it when practicing.

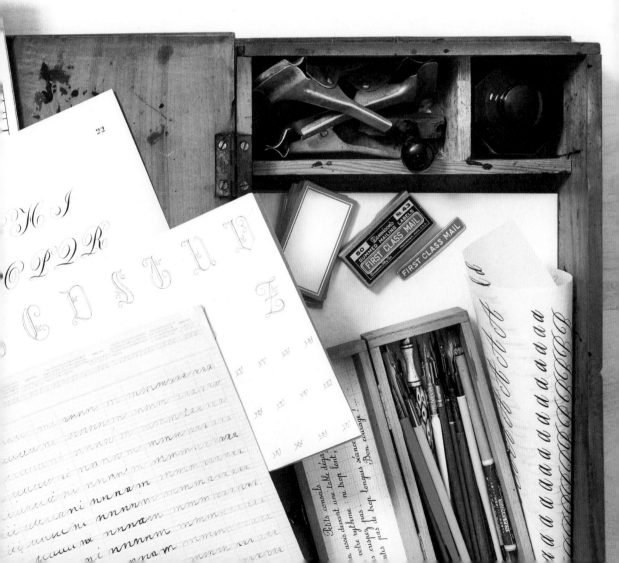

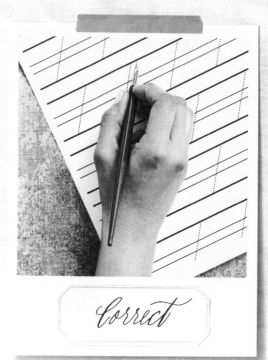

Correct

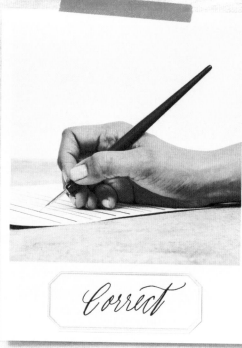

Correct

A Hold the pen with a relaxed grip as close to the nib as possible in the direction of your stroke.

B Angle the pen back, resting on your middle finger between the thumb and index finger.

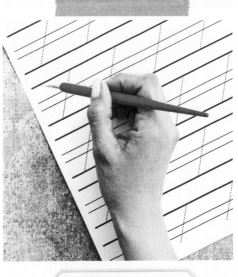

Incorrect

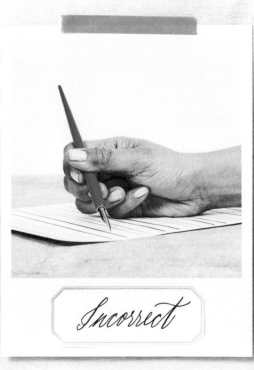

Incorrect

C The pen is perpendicular to the guidelines, ink will not flow properly and may spatter.

D Gripping the pen too high will create a lack of control and be difficult to sustain while writing.

Holding the Pen

It may be necessary to turn your paper so that the wet ink will not smear. No matter the orientation of your grip or the position of your paper, you want the pointed part of your nib to point in the same direction as you are writing.

Holding a calligraphy pen may be quite different than holding a regular writing pen or pencil. Everyone has a different kind of grip for a regular writing tool; this is the case for calligraphy tools as well.

When using a calligraphy pen, your hand should rest lightly on the page, and the movement and control should come from your fingers, not your hand or arm. Hold the pen as close to the nib as you can without touching it (A, B). Holding the pen too far up from the tip doesn't give you the control that you need, plus this position is difficult to sustain (C, D). Angle the pen back to ensure the nib is pointing in the direction of your stroke (A). Notice the way the pen is positioned: if you hold it in a completely perpendicular position, this will hinder the fluidity of your movement and may cause splatters (C). If you are using a sheet with guide lines, make sure the pointed part of the nib is pointed in the same direction as the guide lines, toward the upper-right corner, and position the pen parallel to the dotted guide lines. At this point, check to make sure that your grip is not too tight, which may cause cramping in your hand. Like in yoga when you need to constantly remind yourself to breathe, in calligraphy you need to remember to keep your grip light. Set your intention to stay loose—in grip and in spirit!

Making a Mark

Before you dip the pen into your ink, ensure that the nib is inserted properly and won't wiggle out of the holder. This is easier and cleaner to adjust if you do it before dipping the nib.

Take a look at the nib. Notice the tines that come into a perfect point at the tip, which you won't be able to see once your pen is coated with ink. This point will create lines of varying thickness depending on the pressure: more pressure creates a thick line (often referred to as *shading*), and thin lines come from barely any pressure at all.

Once you are certain that the nib is secure, dip your pen into the ink, ensuring that the nib's vent hole is coated with ink. Take a close look here: if you still see the vent hole, you have not dipped the pen enough and the nib will run out of ink quickly. Re-dip if necessary, then gently tap the nib on the edge of the ink bottle so that any excess does not drip on your paper. Now you are ready to begin!

On a scrap piece or paper, test the ink flow before creating your marks. And be patient with yourself. It takes time to get used to dipping your pen, and confidently making marks with your dipped pen and ink. To keep things simple in the beginning, stick with black ink and smooth practice paper. Make lots and lots of marks—whatever you feel like. The intention here is to get your hand used to the act of dipping the pen so that it becomes intuitive for you. And as you develop that muscle memory, you're also laying the foundation for being able to form letters later on. For example, the hairline stroke (made with very light pressure) that you'll practice on the next spread will be used later in all your upstrokes creating letters. Some of my favorite marks are straight strokes, angled strokes, hairline strokes, star strokes, cross-hatching, ovals, loops, dots, and swirls.

TROUBLESHOOTING
If you are having trouble getting ink to flow and the vent hole is filled with ink, you may need to clean your nib. If you are getting too many splatters, check the position of your pen. Be sure that you're not holding it at too upright of an angle.

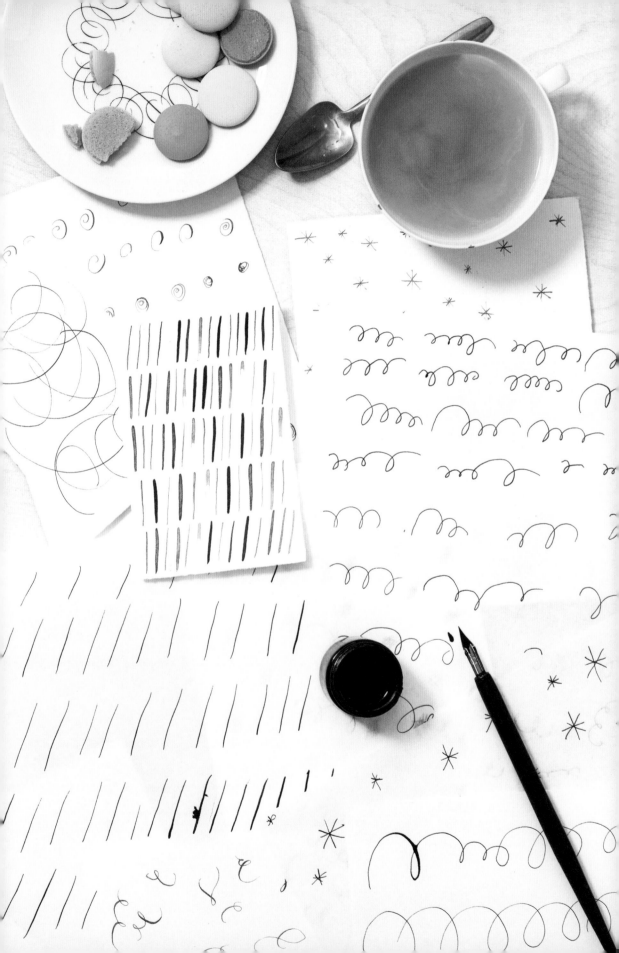

Warm-up Strokes

Before starting any project, warm up. Warm-ups can be quite meditative. In addition to including a good stretch beforehand, try to avoid sitting for more than three hours at a time. And be sure that you are starting at a time when you are least likely to be distracted. There is nothing more frustrating than not being able to concentrate on warm-ups because you are constantly being interrupted.

When you're ready to start with some strokes, gather a stack of papers—roughly ten sheets or so—to create a nice padded surface for your practice. My favorite calligraphic exercises are the compound curve, ovals, and figure eight. You will see a lot of these curves appear when you start writing capital letters.

Compound Curve

To create the compound curve, start your pen at the top right. With very light pressure and a hairline stroke, create an angle down toward the left; use heavy pressure and release in the middle to create the thicker part of the line; then revert back to the hairline at the end. This is a press and release motion. Keep in mind that the key to this stroke is to slow down.

Ovals

Oval strokes are created with thin upstrokes starting from the bottom left, then upward followed by a thick downstroke as you loop toward the right. At first this hairline stroke in the upward direction is tricky and your hand may be shaky. Notice where you are applying pressure and the general shape of your ovals: if you apply pressure too early, your ovals will have somewhat of a pointed shape. If your ovals are pointy, try applying pressure at about two o'clock on the curve.

Figure Eight

The figure eight exercise is done with very light pressure, and comprises a hairline stroke from the left to the right, a heavy downstroke and pressure from the right to the left, and back and forth. Like the compound curve, this is a press and release motion. Note the direction of the downstroke: right to left.

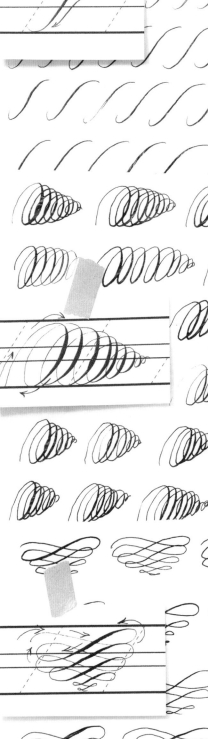

Ready, Set, Go!

You will know when you are warmed up and ready to start a serious project when the ink flows properly from the nib and you can make smooth strokes without splatters. You may feel it just after a few practice strokes, but if you have been carried away with an entire page of swirls, don't worry, I've been there too. Warming up will feel differently from person to person. The way I draw my letters may not be what you are used to, and you may find a way to do your letters that looks quite different from mine. That's exactly the point! Calligraphy should feel comfortable, not frustrating—and believe me, if you have difficulty in strokes, it's easy to get frustrated. If you notice that your pen is scratching, resisting, or splattering, recheck the angle of your pen. You will achieve the best result if your calligraphy pen aligns with the angle in which you are writing (see photos on page 30).

The gift of learning

You may have noticed this already with your warm-up lessons: practice can be very meditative. Keep it positive and be in the moment. This is your time for yourself. Make a cup of tea, listen to some nice music, and get cozy. When I was a beginner I didn't realize how well calligraphy would serve as a way to take time for myself. Let go. Unwind. Be.

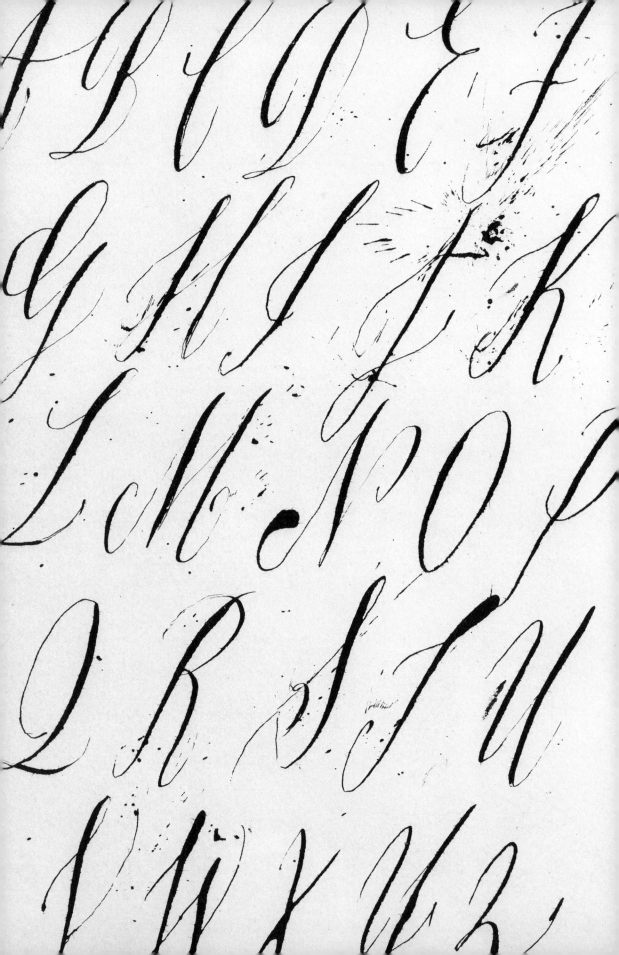

Practice,
Practice,
Practice!

The Alphabet

When you can get ink flowing consistently from your nib and are able to make smooth strokes without splatters, you are ready to start practicing the alphabet. It's best to start with one letter at a time, filling an entire page with A's, B's, etc. You can save these practice sheets to be used for projects later in this book.

Majuscules & Minuscules

You may come across the words *majuscules* and *minuscules* in lettering books. These are the formal terms for the alphabet's uppercase and lowercase letters, respectively. The size of a lowercase letter in relation to an uppercase letter is called the *x-height*.

In the examples that I have provided on the following pages, the numbered arrows show you the order in which I make the strokes that form my letters. I use the lines as a general guide so that I know how to size my letters. You will notice that I tend to go outside the lines quite a bit. It's absolutely okay to do this. You will notice words such as *upstroke*—a stroke that heads upward, *downstroke*—a stroke that angles downward with applied pressure, *hairline*—a thin stroke that is made with very light pressure, and *comma dot*—a comma connected to a dot made with your pen.

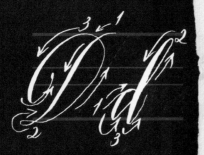

A begins with a reversed loop from right to left with pressure on the downstroke into a hairline upstroke to a point followed by a downstroke with pressure ending with a hairline curve up and comma dot (teardrop shape). Finish with a wave-like hairline cross slightly above the center.

a begins with a curved downstroke with pressure, a hairline up, and then pressure on the downstroke, and a hairline curve upward to finish.

B is formed with a compound curve downstroke, to create the body, moving into a tiny loop at the bottom followed by an upward hairline stroke to create the lower part of the *B*, a second smaller hairline loop upward extending to the left of the body stroke into a curved oval downstroke with pressure ending in a hairline loop upward to finish.

b starts with a hairline stroke up and then loops from right to left into a thick downstroke, with a small hairline curve upward and inward toward the bottom third of the downstroke, with an exit stroke from the connection.

C is formed with a hairline stroke just to the left of an oval shape, pressure on the downstroke, and a hairline stroke upward to finish.

c starts with a hairline upstroke curving toward the right, then back around from right to left with pressure on the downstroke to form the letter, closing with a hairline stroke up.

D is formed with a compound curve downstroke, moving into a tiny loop at the bottom followed by an upward hairline stroke to form the body of the *D* into a curved oval downstroke with pressure ending in a hairline loop upward to finish.

d starts with a hairline upstroke curving toward the right, then back around from right to left with pressure on the downstroke, continue with a hairline upstroke make a loop into the downstroke, with pressure, finishing with a hairline upstroke.

E starts with a tight hairline loop from the left heading upward to create an oval. Add pressure to form the top oval from right to left, then use the same pressure to form a bigger oval at the bottom portion of the letter. End with a curved hairline up.

e is formed with a hairline stroke starting just above the baseline continuing upward to create a small loop, followed by pressure on the downstroke, and a hairline curve upward to finish.

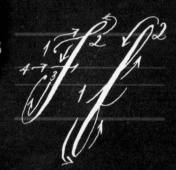

F is formed with a wave-like hairline from left to right followed by a tiny loop into a compound curve downstroke, with pressure, into an upward reversed hairline loop and comma dot. Finish with a short hairline and slanted backstroke slightly above the center.

f begins with a hairline in an upward direction. Make a flat loop and then put pressure on the downstroke, go below the baseline, and then loop upward and inward toward the bottom third of the downstroke, with an exit stroke from the connection.

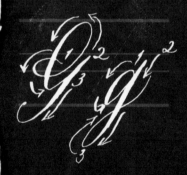

G starts with a hairline stroke from the left and then loops up as if you are making the letter C, pressure on the downstroke, then turning upward the line extends slightly to the right and finishes with pressure on the last downward stroke, with a loop to the left to finish the letter.

g starts by writing a letter *a*, and continues the second downstroke below the baseline, with pressure, making a hairline loop upward from right to left crossing the downstroke near the baseline to finish.

H is created with a wave-like hairline upstroke from left to right followed by a tiny loop into a compound curve downstroke, with pressure, into a small loop at the bottom crossing upward into another small loop at the top followed by a parallel downstroke with pressure ending with a hairline curve up and comma dot.

h is formed with a hairline upstroke loop from left to right into a thick downstroke, a hairline up, then pressure on the downstroke and a hairline curve upward to finish.

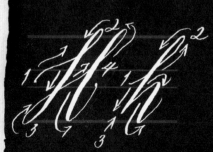

I starts with a slight figure-eight hairline upstroke from left to right, making a small loop at the top, moving into a compound curve downstroke with pressure and a reversed hairline loop and comma dot at the end.

i is created with a hairline upstroke followed by a short downstroke with pressure and a hairline curve upstroke to finish. Dot your *i* a little above the downstroke and in line with the slant of the letter.

J starts like the *I* but makes a larger figure-eight shape hairline in the upward direction, making a small loop at the top, and then a compound curve downstroke with pressure followed by a hairline loop upward from right to left crossing the downstroke near the baseline to finish.

j is created with a hairline upstroke followed by a downstroke, with pressure, that continues below the baseline, into a hairline loop upstroke from right to left crossing the downstroke near the baseline to finish. Dot your *j* a little above the downstroke and in line with the slant of the letter.

K starts with a wave-like hairline upstroke from left to right, making a small loop at the top, moving into a compound curve downstroke with pressure into an upward reversed hairline loop and comma dot. The next part is a hairline from the top-right to the left, just touching the mid-point of the downstroke and with pressure on the last stroke. End with a loop and comma dot.

k starts with a wave-like hairline upstroke from left to right, making a small loop at the top, into a thick downstroke, a hairline up to form a small loop to the right, then pressure on the downstroke and a hairline curve upward to finish.

L begins with a sweeping hairline loop from the left extending upward making a loop at the top and moving into a compound curve downstroke, with pressure, into a small hairline loop finishing with a wave-like hairline stroke and comma dot.

l starts with a hairline stroke up, into a loop with pressure on the downstroke and a hairline upstroke to finish.

M is formed with a reversed loop from right to left with pressure on the downstroke into a hairline upstroke to a point followed by a downstroke, with pressure to the baseline. Continue with a hairline upstroke to a point followed by a downstroke, ending with a hairline curve up and comma dot.

m is a hairline upstroke followed by a short downstroke with pressure, a hairline up to create the shoulder shape, and then another short downstroke with pressure, repeat the up and down strokes one more time and finish with a hairline curve upstroke.

N is formed in a very similar way to the *M*, with a reversed loop from right to left with pressure on the downstroke into a hairline upstroke to a point followed by a downstroke, with pressure, to the baseline. Continue with a hairline upstroke into a righthand loop, pressure on the downstroke and curl up to a comma dot.

n begins with a hairline upstroke followed by a short downstroke with pressure, a hairline up to create the shoulder shape, and then another short downstroke with pressure. Finish with a hairline curve upstroke.

O is created with an oval shape starting from right to left, with pressure on the downstroke. Continue up with a hairline stroke that connects and completes the letterform.

o is simply a smaller capital *O*—an oval shape starting from right to left with pressure on the downstroke, then a hairline to connect—starting at x-height.

P is formed with a compound curve downstroke with pressure, into an upward reversed hairline loop and comma dot. Lift your pen to start a little to the left of the compound curve and add pressure to form the bulge of the letter.

p starts with a hairline upstroke, followed by a downstroke, with pressure, continuing below the baseline, into a tight hairline upstroke loop from right to left, then crossing the downstroke to create the bulb of the letter. Continue with a short oval downstroke with pressure to connect at the baseline. Finish with a hairline curve upstroke.

Q starts with a hairline beginning just below the x-height moving right to left upward creating a reverse oval with pressure on the downstroke, into a small hairline loop, with slight pressure, finishing with a wave-like hairline stroke and comma dot.

q starts by writing a letter *a*, and continues the second downstroke below the baseline, with pressure, making a tight hairline loop upward from left to right touching the downstroke at the baseline with a short exit stroke to finish.

R is formed with a compound curve downstroke, with pressure, into an upward reversed hairline loop and comma dot. Lift your pen to start a little to the left of the compound curve and add pressure to form the bulge of the letter touching the mid-point of the downstroke and with pressure on the last stroke. End with a hairline upstroke.

r is made with a hairline upstroke to x-height and a small loop from left to right that crosses the first line. Pressure on the downstroke leg of the *r* and end with a hairline upstroke.

S starts with a curved hairline upstroke into a small loop at the top, followed by a reversed compound curve, with pressure, and a curved inward loop with pressure at the end of the stroke.

s is formed with a hairline upstroke to x-height followed by pressure on a reversed compound curve, looping in from right to left.

T is formed with a wave-like hairline from left to right followed by a tiny loop into a compound curve downstroke, with pressure, into an upward hairline reversed loop and comma dot.

t starts with a hairline upstroke to a third from your x-height, followed by a heavy downstroke and hairline upstroke to finish. Cross your letter with a wave-like hairline stroke.

U is a hairline up, a looping over into a downstroke, with pressure, then a parallel upstroke to the top followed by a downstroke, with pressure, and finally a hairline upstroke.

u starts with a hairline stroke up to x-height. Then a short downstroke, with pressure, curve up with a hairline, and create a second downstroke, with pressure, ending with a hairline upstroke to finish the letter.

V begins with a wave-like hairline upstroke from left to right followed by a tiny loop into a compound curve downstroke, with pressure, into a small loop at the bottom crossing the downstroke upward with a hairline upstroke to the top.

v is made with a hairline upstroke to x-height followed by a downstroke, with pressure, to the baseline and then upward to the right with a hairline upstroke.

W begins with a V and adds a small loop at the top of the last hairline upstroke into a compound curve downstroke, with pressure, into a small loop at the bottom crossing the second downstroke upward with a hairline upstroke to the top of the letter.

w begins with a v and adds a second downstroke, with pressure, to the baseline and then upward to the right with a hairline upstroke.

X is created with a hairline upstroke loop followed by a downstroke, with pressure, to the baseline and a hairline upstroke. Complete the letter with a delicate hairline downstroke from top-right to bottom-left through the mid-point of the first downstroke.

x starts with a hairline upstroke at x-height followed by a downstroke, with pressure, then a hairline upstroke. Cross the downstroke with a hairline stroke from top-right to bottom-left to finish.

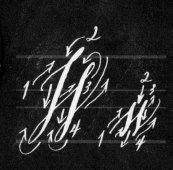

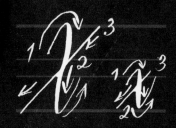

Y is a hairline upstroke looping over into a downstroke, with pressure, looping into a hairline upstroke to the top followed by a downstroke, with pressure, below the baseline into a hairline loop from left to right upward crossing the downstroke at the baseline to finish.

y is created with a hairline upstroke up to x-height, looping over into a downstroke, with pressure, then back upward with a short hairline stroke to x-height and then a downstroke, with pressure, below the baseline into a hairline loop from left to right upward crossing the downstroke at the baseline to finish.

Z starts with a hairline upstroke just above the centerline, similar to writing the numeral 3, with a righthand loop with pressure on the downstroke to the mid-point followed by a second righthand loop with pressure on the downstroke below the baseline into a hairline loop from left to right upward crossing the downstroke slightly above the baseline to finish.

z is made with a hairline upstroke from the baseline to x-height forming a righthand loop with pressure on the downstroke to the baseline followed by a second righthand loop with pressure on the downstroke below the baseline into a hairline loop from left to right upward crossing the downstroke slightly below the baseline to finish.

When practicing the lowercase
letters, you may find that they
will come more easily than
capital letters. That is because,
assuming you had any kind of
traditional cursive handwriting
instruction in school, your
muscle memory is still alive in
your hands.

Connecting Letters

No matter how imperfect or uneven one's writing may be, it
is important that it is legible. When connecting letters to form
words, giving each letter its own space to breathe, allowing
each word to amplify its meaning, is a fine balance. You can
achieve this by the way you space your letters or the angle at
which you choose to write. For example, typically I do not connect
my capital letters with the lowercase letters that follow them.
This allows for a little bit of flourish or swash—like a drop cap in
a well-designed magazine layout. But if it feels more comfortable
for you to connect your capital and lowercase letters, and you like
the visual balance of it, by all means continue to do it.

Words & Phrases

When you first are getting used to connecting your letters,
you'll find that many letter combinations occur in the different
words that you will write. An exercise that I find very helpful is to
choose two random letters and repeat the letters together. This
will allow you to concentrate on the letterforms rather than the
word itself.

Adventure
Admire
Authentic

Believe
Beauty
Bliss

Connect
Create
Calm

Gratitude
Gather
Graceful

Healing
Harmony
Healthy

Imagination
Intuitive
Inspire

Meaningful
Meditate
Marvelous

Nature
Nourish
Nostalgic

Open
Optimistic
Original

Soul
Smile
Spontaneous

Thankful
Today
Tranquil

Upbeat
Unwavering
Unique

Youthful
Yearning
Yes

Discover
Delight
Dazzle

Elegant
Explore
Enjoy

Friendship
Family
Flourish

Jovial
Joy
Jubilation

Knowledge
Kind
Kiss

Loveliness
Luminous
Laugh

Peace
Purpose
Pleasure

Quirky
Quiet
Quaint

Relax
Respect
Restore

Visualize
Voyage
Value

Wonder
Whole
Welcome

Xanadu
X Factor
XO

Zest
Zeal
Zing

Here are some suggested words—some of my favorites for both their positive meaning and their technical flow when handwritten—to practice writing and connecting letters.

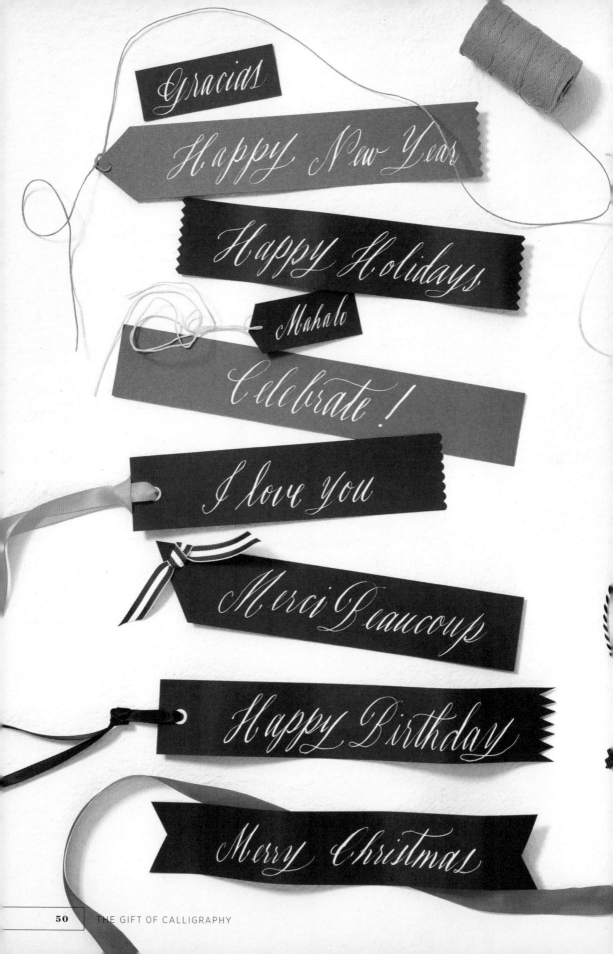

Je t'aime

Ciao

Je amo

Thinking of you

Forever

Be Mine

Congratulations

Bon Anniversaire

Bon Voyage!

Thank You

Greetings

Now that you've practiced connecting letters into words, you can write phrases. The phrases on this page are often used in invitations and greeting cards, and by practicing them you'll be well on your way to creating your first real project in chapter 5. The more you practice, the better you'll get—your letters, words, and phrases will flow onto the paper with ease.

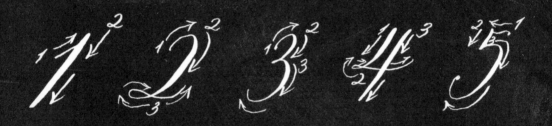

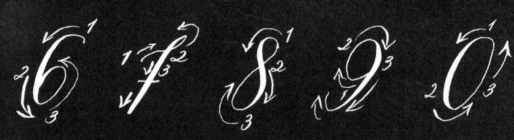

Numerals & Symbols

By now you may be getting used to creating your letters by applying different pressure to create thick and thin strokes. When you are ready to start writing out other characters such as numerals and symbols, the same of amount of pressure will apply for your upstrokes and downstrokes. Remember that a downstroke creates a thick line, and very light pressure creates a thin hairline—whether it is a horizontal or diagonal line.

The characters here are common in everyday handwriting. They are numbered and arrowed as examples of how I create them, but write them in the way that feels most comfortable for you.

Making Lists

After you've practiced making marks, individual letters, simple phrases, numerals, and symbols, it's fun to put your skills to use. Try using calligraphy for writing your everyday lists. I love writing lists! We all make them, even if it's only a simple list of groceries. But when you use calligraphy to write them, you get to practice your craft and incorporate art into your daily life. You may think your busy schedule won't accommodate time for art, but by incorporating calligraphy into a simple task, you've been artistic and creative today!

When you want to practice calligraphy but don't know what to write, here are some topics that will inspire you to create your own lists: *grocery list, favorite flowers, favorite foods, things you're grateful for, titles of favorite movies, titles of favorite books, places you'd like to visit, a wish list, favorite song titles, names of favorite people in your life, life goals, recipes . . .*

Give a gift to yourself

Calligraphy is wonderful because you are choosing to make time for something that you love to do—a gift we often deny ourselves. Making time for your well-being through daily calligraphy practice allows you to pause, be creative, and write down positive things. I am living proof that a positive attitude has tremendous healing power.

abcdefghy

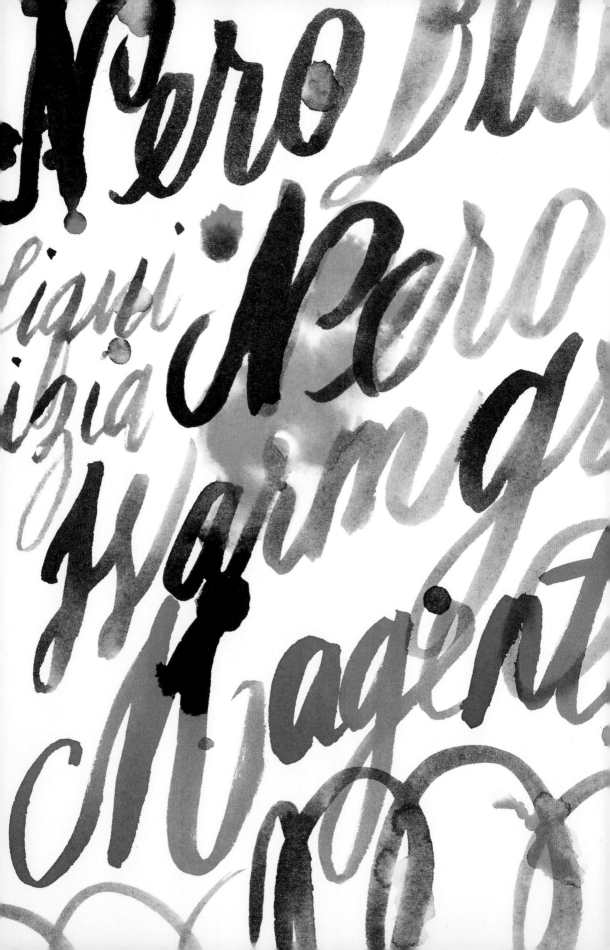

Experimenting with Colors & Materials

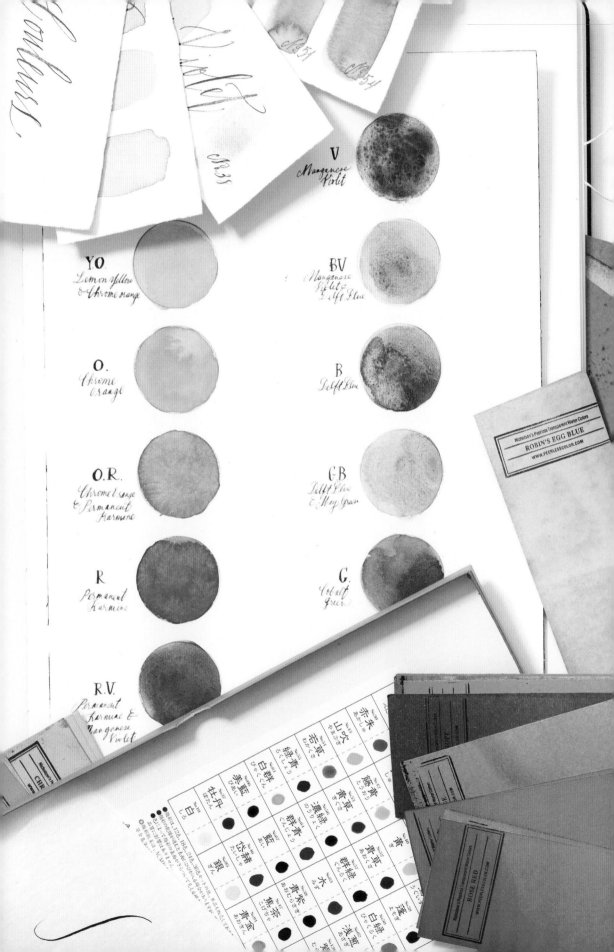

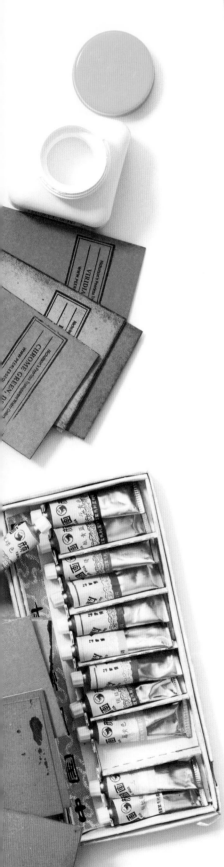

Incorporating Color

Calligraphy written with black ink on cream paper has an understated and elegant look. It allows for the artwork to stand out on its own—and sometimes that's really all it needs. Much of my work is black-and-white, as I prefer to use black sumi ink and white or cream paper for several reasons. First and most important, a pen, paper, and ink combination must be perfectly harmonious in order to get consistent results. If I'm on a deadline for editorial work or a commission, I rarely have time to experiment with getting a new ink and paper color combination to work. While color is lovely, adding it means changing ink, and this may present potential challenges—such as getting it to flow through your nib smoothly—and disrupt the paper-pen-ink compatibility that you have achieved while practicing and working with black ink.

Second, sometimes you might need to create *camera ready* artwork, as is required by most professional printers. To achieve this, you need to make sure your work is as clean as possible, erasing mistakes or altering the piece after it's scanned and on the computer. This is simpler with black-and-white artwork. Before the invention of computer editing programs, the term *camera ready* meant that the work done by hand had to be pristine with a strong contrast, and the artist would cover mistakes with white paint directly on the final artwork. If you create your artwork using color, it may not provide the best contrast in order to create a film used in most commercial printing processes.

For these two reasons, and quite simply because it suits my personal aesthetics, I default to black ink and white paper. But that's not to say I don't adore color, because I do! There are times when color will elevate the look of your calligraphy in ways you may never have expected. Color provides many things: harmony, contrast, unity, rhythm, and emphasis. Choosing how to incorporate it into your work is so personal, and it wildly expands your creative possibilities. (Limitless possibility can also be daunting, though—another reason why I always start with just black ink on white paper!) In calligraphy you can incorporate color simply by changing the paper or ink color. Even just flipping your palette to white ink on black paper, for example, creates an entirely different impact and impression.

Tools for Creating Color

When working with colors, these are some of the tools that I like
have on hand in my studio. That way, when I want to mix a custom
color for a special project, I can usually start the work right away
without having to visit the art store. Mixing custom colors is fun
and easy to do. It's best when you have time to experiment a little
before you begin a project. I prefer to mix my own colors for those
times when a particular hue is not available in a commercially
premixed color. I have found that when I am trying to do this it's best
to reference a color system, such as the Pantone Matching System
(PMS) or a paint swatch found at a paint or hardware store. Use
it as a reference and goal so that you are not just randomly mixing
colors together. It's also easier to communicate a particular color to
someone else if you are each referring to the same color swatch.

1 Color reference
Something, such as a Pantone color guide or paint swatches, to reference when you are looking for color ideas and inspiration.

2 Gum arabic Aids in making the ink water- and smudge-proof. I prefer the liquid form, but it's available as a powder, too. Be careful, though, as adding gum arabic to your ink may thicken the ink—be sure to test your mix.

3 Gouache A water-based opaque paint that must be thinned with water to achieve the proper consistency for pointed pen calligraphy. Gouache is the paint I use most for mixing custom colors.

4 Jars A selection of small glass jars with lids will allow you to properly store inks you mix for consistency and/or color.

5 Labels Use to indicate ink colors on jars.

6 Distilled water Use for diluting and mixing. Unlike tap water, distilled water is free from impurities and will extend the shelf life of your mixtures.

7 Metallic inks and paints Great for adding extra shine and fun details in your work. Don't be afraid to experiment!

8 Small paint brush Use to mix colors together and to load your nib.

9 Assorted watercolors A transparent paint available in bottles (liquid), pans, or tubes. I prefer the liquid form as it is the most ink-like and requires less work to achieve a nice consistency for pointed pen writing.

10 Powdered pigments Use as a base for mixing watercolors and acrylic paints from scratch. (Note: These require a respirator mask.)

11 Designated measuring spoons Use for measuring, as the name suggests. Keep a set designated for art/craft use only.

12 Tiny spatula and popsicle sticks Use to scoop paint out of jars.

13 Acrylic paints Good for projects that might feature rough or nontraditional surfaces like wood and stone. Acrylic is inherently water-resistant but must be thinned with water to achieve the proper consistency for pointed pen calligraphy.

White Ink on Dark Paper

The look of white writing on black paper makes a beautiful contrast. It is stark and eye-catching because it's the opposite of what we're accustomed to reading every day. You can achieve the same contrast while using other colors such as navy blue, charcoal gray, and red. Whenever I see my workshop students struggling because they're very attached to using guide lines for their letterforms, I suggest trying white ink on black paper. It is impossible to see through darker paper to the guide sheet, so you can really focus on the letterform by following the numbered order in the example. If you need your words to be perfectly straight, you can pencil them in first and then erase the lines (with a black eraser!) once the ink is dry.

Two of my favorite black papers are Strathmore Artagain in Black and Neenah Astrobrights in Eclipse Black.

When working with white ink, have a small cup of water on hand, because the tip of the nib can dry out more easily than with black ink. Dipping the very tip of the nib into the water while it is still loaded with white ink helps to get it to flow from the nib again.

HOW-TO: *Diluting White Ink*

MATERIALS

Dr. Ph. Martin's Bleedproof White ink

Measuring spoons

Small glass jar with lid

Distilled water

Small paintbrush

Pointed pen

Pipette

Black practice paper

NOTE

Distilled water will help your mixture last longer, but tap water works just fine for diluting white ink.

My favorite brand of white ink is Dr. Ph. Martin's Bleedproof White. It has a paste-like consistency, and I dilute it with distilled water to get it to my preferred viscosity. You want white ink to contrast dramatically on dark paper, so it's important to get your mixture to be truly opaque. Here's how to get that perfect opacity.

1 Scoop out about 1 tablespoon of white ink into a small clean jar. Add 2 tablespoons of distilled water to the ink, a little at a time, and mix with a clean paintbrush until the ink is the consistency of heavy cream.

2 Test the mixture by painting it onto your nib instead of dipping it. The mixture should flow through your nib without getting clogged. If it doesn't, it is too thick; use a pipette to add a few more drops of distilled water at a time until the mixture flows through the nib again.

3 Make practice marks on black paper and let them dry to make sure you've achieved the opacity you are looking for. If the mixture is too thin, it will not be opaque when you write, but instead will look transparent. If this happens, add about ¼ teaspoon of white ink at a time until you get the desired opacity.

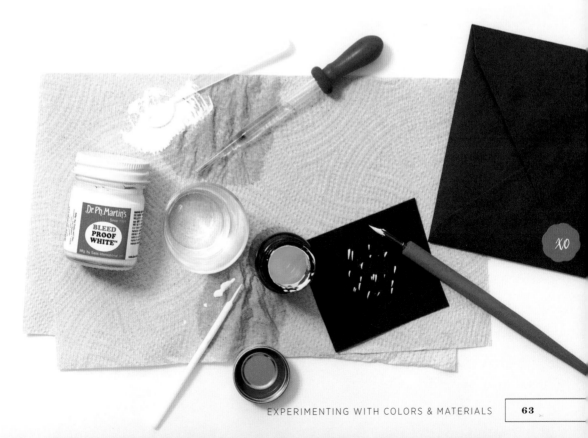

Working with Color Paints & Inks

Once you have practiced mixing the perfect consistency of white ink and are comfortable working with it, you can experiment with mixing other colors. Here is a basic breakdown of how to mix colors using various mediums.

Watercolors

Watercolors are wonderful to work with thanks to their vast range of color, and the way the paint interacts with water results in such organically gorgeous shades—often exceeding your expectations. And watercolor paint's translucency enables you to easily layer your text on top (after letting the paint dry completely).

Watercolor paints are available in pans, tubes, or liquid (concentrated) form. For pointed pen calligraphy, I find liquid watercolor the easiest to use because it behaves like ink. Brands such as Dr. Ph. Martin's and Ecoline have quite vibrant colors. If you choose to use watercolor in pans (a very commonly sold format—popular brands include Schmincke and Kuretake), simply dip a wet paintbrush into the pan, pick up some paint, and brush it onto your nib.

There are many papers tailored specifically to watercolors. I prefer hot press paper, which is a smooth paper similar to mixed-media or drawing paper, but doesn't absorb water as quickly so you can play with the paint a bit before it dries.

If you'd like specific project instructions for experimenting with watercolors, see Watercolor Placecards (page 91) and Watercolor Swatches (page 163).

HOW-TO: *Mixing Gouache*

MATERIALS

Pipette

Gouache

Clear glass jar with lid

Small paintbrush

Distilled water

Measuring spoons

Liquid gum arabic

Pointed pen

Labels

NOTE

When adding gum arabic to gouache, sometimes the color will dry darker. Once it's dry examine your test in proper lighting—preferably natural daylight.

Unlike watercolors, which are inherently transparent, gouache is a water-based opaque paint that must be diluted with water to use with a pointed pen. There may be times when you would like to match a Pantone chip or a color swatch. In that case you may want to experiment with mixing gouache to get the color just right. Test out small amounts by painting the mix onto your nib and then allow your strokes to dry to see if the color is correct. Sometimes changing the color of your paper will also affect the ink color. Adding liquid gum arabic to your gouache mixture will help make it somewhat water- and smudge-proof.

1 With a pipette, combine two or more colors of gouache in a jar until you have about 1 tablespoon of paint.

2 Mix the colors with a paintbrush to ensure that they are combined completely. When you achieve the color you want, use measuring spoons to add distilled water in small amounts, about ½ teaspoon at a time, until the paint is the consistency of heavy cream.

3 Add liquid gum arabic, a drop or two at a time, to your mixture. Doing this a little at a time will help your mixture adhere to the paper better. You will not see much of a change in the mixture right away, but once it is dried on the paper you will notice a slight sheen to the color. Adding too much gum arabic to the paint will affect the flow of the mixture through the nib.

4 Test the mixture by writing something with your pen.

5 Write the name of your mix on a label and adhere it to the jar.

Premixed Colored Inks

Premixed inks, typically acrylic-based, are available from your local art supply store in the entire spectrum of colors. These tend to be thick and to dry on paper as a slightly raised surface. After they have dried, premixed inks are also water-resistant, which makes them wonderful for things such as menus or placecards that will be in close proximity to food and drink. You can thin these inks with water so that they make a desired consistency when used with a pointed pen.

Despite the wide variety of premixed colored inks, you still might not find the exact hue you want—or maybe you just enjoy creating something completely custom. Mixing custom colors is easy (follow the steps on the previous page, "Mixing Gouache"), and is a terrific skill to have for when you need only a bit of a particular color and don't want to purchase a whole premixed bottle.

Natural Colored Inks

Natural colored inks are made with pigment from things such as walnuts, grass, fruits, and vegetables. Because they are made from plant-based products, the colors vary each time they're made, and they tend to produce an earthy palette. Also, natural pigments are not lightfast and therefore may fade more quickly than colors mixed with gouache. You may discover that this actually creates a nice effect, like the faded patina on a vintage piece.

You can create pointed pen inks from natural pigments used for dying fabrics. Colors such as indigo and walnut are available in powder form from stores like A Verb for Keeping Warm in Oakland, California. As with gouache (see page 65) and other paints, you will need to mix the powdered pigment with distilled water and a few drops of gum arabic to create an ink of the desired consistency.

Metallic Colors

Working with metallic inks, especially liquid ones, can be quite tricky. Metallic pigment tends to separate from the liquid mixture and therefore requires constant mixing. If you dip the nib directly into the ink, eventually the nib will get coated with the metallic pigment and require lots of cleaning between strokes. When working with metallic colors in pans, such as those made by Kuretake and Finetec, first you will need to wet and mix the color in the pan with some water before you can paint it on the nib. This can be a slow process, so I recommend it only for spot metallic colors.

Of all the metallic colors, I work with gold the most, and my go-to gold ink is Dr. Ph. Martin's Copper Plate Gold (11R). It is available in a jar with a dropper cap. The best way to keep the ink mixed is to remove the dropper cap and mix with a short paintbrush directly in the bottle, then use that brush to paint the ink onto your nib (instead of dipping your nib into the ink).

HOW-TO: *Masking Fluid*

Masking fluid, also called Frisket, is a liquid mixture of latex and ammonia that creates a resistance on paper, "masking off" the areas that you don't want to be painted. When you write using masking fluid instead of ink and then paint over it, the fluid resists the paint and the words show through as the color of the paper. Masking fluid is thin enough to pass through a pointed nib, and dries into a rubbery film. You'll need to work quickly, this mixture will solidify as it dries. Look for tinted masking fluid so that it is easy to see once it dries on your paper.

1 Pour some masking fluid into a jar and dip the pen into the mixture. If you allow the masking fluid to dry on the nib, simply peel the dried substance off the nib. You can also use water to clean the nib while the masking fluid is still wet.

2 Write on your paper, allow the masking fluid to dry completely, and then use a brush to paint over the writing with watercolor or gouache. Keep in mind that the writing will remain the same color as the paper.

3 Use a soft eraser to lift off the masking fluid—discovering your words emerge from the color is an oddly satisfying process. Try to resist rubbing off the dried masking fluid with your fingers, as this could damage the paper.

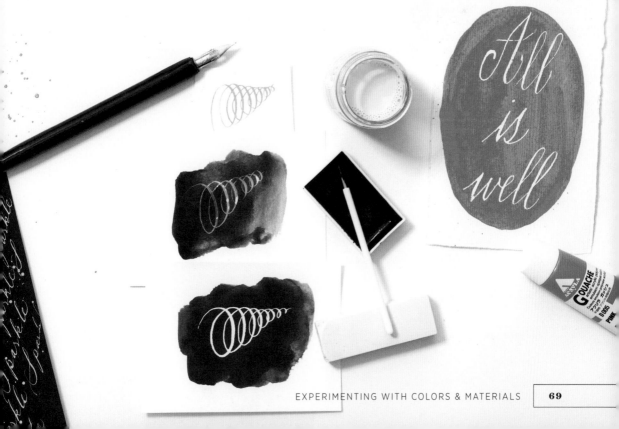

Experimenting with Different Pens

An assortment of pointed pens and calligraphy nibs will enable you to create playful and expressive letterforms. They are fun to play around with and may help you to discover a different style to claim as your own. The pens shown here are just a small selection from my collection but they show a range of effects depending on the type of pen you are using. I encourage you to try new nibs and draw a range of letterforms with each. Remember: the pen holder, nib, ink, and paper need to work in harmony, so trying different nibs will require patience. Work slowly and don't change too many variables (like nib, ink, and paper) all at once.

Below is a chart showing various pointed pens and the line and letterform variations that each creates. When experimenting with the nibs listed here, start with black ink and smooth practice paper. When you gain more confidence, go ahead and change up the paper or the ink color.

1 Mapping pen nib
Used for tiny details and smaller pointed pen writing. Also known as a maru pen, which means "map" in Japanese. Shown here is one of my favorite vintage holders, made by Tachikawa.

2 Glass dip pen
Made completely of glass, the tips don't have the flexibility that metal nibs have. Shown here is a vintage pen from my collection.

3 Mitchell Elbow nib
Used with straight pen holders only, this nib has a built-in 45-degree angle like an oblique nib holder.

4 Brause 361 Steno nib
Also known as the Blue Pumpkin, creates a varied thick and thin line, used for larger writing.

5 Mitchell Scroll nib No. 40
Used for creating decorative borders, but also fun for writing larger letterforms.

6 Ruling pen
The pen's dial adjusts the line thickness. Designed mainly for creating ruled lines. The big A and Z that start and end this book were made actual size with this pen. Vary the pen angle to create thick and thin lines.

7 Brause Music nib
Used for creating staff lines for music, but also great for expressive letterforms.

8 Mitchell Automatic pen
Creates five lines like the Brause music nib, but holds ink better and is more consistent due it's unique design.

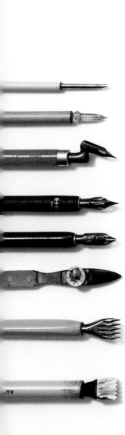

HOW-TO: *Pictorial Calligraphy*

MATERIALS

Smooth card stock
or paper

Pencil

Pointed pen

Ink

Eraser

With pictorial calligraphy, you can easily incorporate your
calligraphy into fun and easy-to-create illustrations. To simplify
things, use basic shapes such as hearts or circles. As with any
new technique, sketch out a few ideas before you create final
artwork. If you're more comfortable penciling in your design
beforehand, keep in mind that pencil marks covered with light-
colored inked lines may be hard to erase. (On page 209 you will
find a calligraphed pear I made to help get you started.)

1 Draw or trace a shape onto a sheet of card or paper with a pencil.
I chose the simple shape of a lemon with a leaf.

2 With a pointed pen and ink, fill the shape with warm-up marks or
calligraphy. I used an easy lemonade recipe. Pay attention to how
your marks are filling up the shape and the texture that they create.

3 Add extra flourishes or oval marks to help fill and define the shape.

4 Allow to dry completely, and then erase the penciled outline.

Roman Lettering

When you look at roman-style lettering, you will notice that the characters have well-balanced proportions. Roman lettering was originally carved into stone with chisels, and characters were developed with straight lines and a serif (the lines finishing off the strokes of the letters). Today, *roman type* refers to upright text—as opposed to italic text, which slants.

Calligraphy is most commonly written on a slant and with flourishes, but play around with cleaner, more upright serif and sans serif styles, too, which are less traditional and thus lend a more contemporary look. And since roman lettering is less common, there are fewer expectations around how it should look. Only in recent years have I started developing this style for myself, and I have that wonderful feeling of being a beginner—uncertain marks, quirky, shaky, and perfectly imperfect. If you're looking for examples to imitate, I like Bodoni and Times New Roman fonts.

See pages 200–201 for the Roman alphabet I created. Use it as a practice guide and starting point for your own typographic style.

No.9
Aster

January 23, 2018

Borage
Chervil
Lemon thyme
Lovage
Lemongrass

Aa Bb Cc
Dd Ee Ff
Gg Hh Ii
Jj Kk Ll
Mm Nn Oo
Pp Qq Rr

Ss Tt Uu
Vv Ww Xx
Yy Zz
0 1 2 3 4
5 6 7 8 9
. , ? ! & *

I II III IV
V X L C
D M () { }
No. ¼ ½
@ % < >

MATERIALS

Tracing paper

Image or lettering to copy

Pencil

Bristol board

Tape

Pointed pen

Ink

NOTE

See Templates pages 205–207 for flower drawings that you may use for this technique.

HOW-TO: *Blotted Line Technique*

While visiting the Andy Warhol Museum in Pittsburgh, I saw a video exhibit of his blotted line technique—a simple printmaking process he often used. Although not as well known as his pop art, Warhol's commercial pen-and-ink work and drawings from the 1960s—often made in collaboration with his mother, Julia Warhola—always inspire me as great examples of imperfect lettering. Often he would inject color with watercolor or gouache. Here's how to experiment with Warhol's blotted line technique.

1 Place a piece of tracing paper on top of something you'd like to copy, and trace the image with a pencil. Or, better yet, draw your own original image with pencil on the tracing paper.

2 Place your drawing on top of a blank piece of Bristol board and tape them together along the right side, creating a hinge.

3 Open the taped pieces so that the backside of the tracing paper is facing up and your drawing appears reversed.

4 Using pointed pen and ink, trace the lines that you see on the backside of the tracing paper.

5 While the ink is still wet, close the tracing paper over the Bristol board and press the wet ink onto the board. Press with your fingers along all the lines, creating blotted lines.

6 Repeat steps 4 and 5, working the drawing in sections before the ink has a chance to dry. When you have completed the process, slowly peel off the tracing paper from the board and remove the tape. Let the ink dry completely.

Pointed Brush Calligraphy

Brush lettering is lovely and loose, free and expressive. It instantly feels different than writing with a nib. For a simple brush exercise, take a stack of blank paper and just write words—anything that comes to mind. (At a loss for what to write? Refer back to Connecting Letters, pages 47–49, or Making Lists, page 54.) For the most part, write as you've been practicing with the pointed pen, applying more pressure for a thicker line and less for a hairline.

Experiment with an assortment of brushes—some with fine points, some larger ones that are made for Japanese and Chinese calligraphy. As for inks, you can use a brush with the same inks that you use for pointed pen work—simply dip your brush and go. You can even start with sumi ink and dilute the mixture to create shades of gray. No matter the ink you use, you will get lovely splatters depending on the type of brush you use.

Actually, one of my favorite techniques is to use a Pentel brush pen, which has an ink-filled cartridge inside, but I am a bit impatient at times and end up dipping the tip into a container of sumi ink.

If you'd like specific project instructions for experimenting with brush calligraphy, see Gift Wrapping with Calligraphy (page 99) and Brush Lettering Tote Bag (page 123).

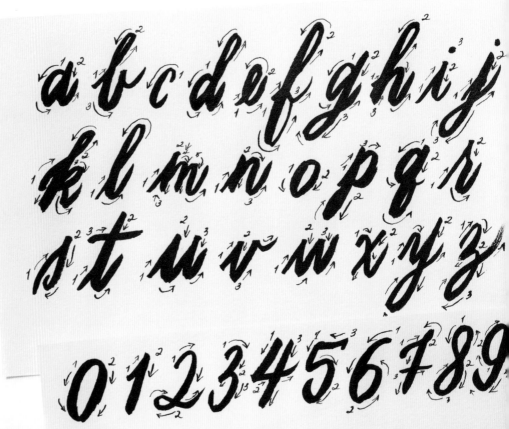

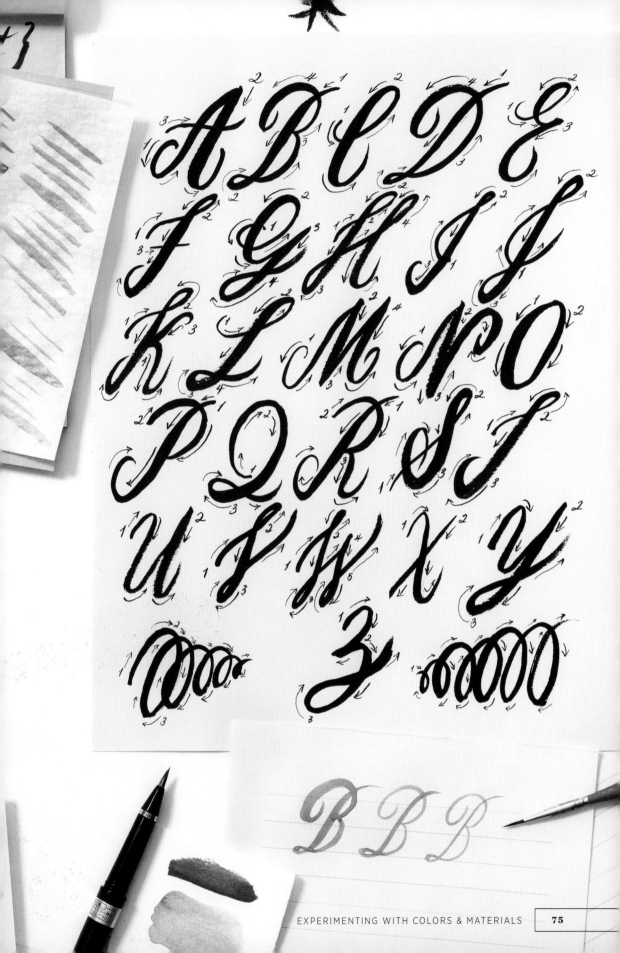

Writing on Nontraditional Surfaces

Using wood, fabric, leather, or other surface in lieu of paper creates unique, lasting artwork. You can also create a calligraphic look using writing implements that aren't specifically designed for calligraphy. For example, there are a range of chalk markers or even oil-based paint pens.

Fabric

A practical approach to writing on fabric is to use a brush. You can experiment with fabric pens, too.

There are also a few techniques to transfer your work onto fabric without having to write directly on the material itself. If you know how to embroider, transfer your calligraphic designs to your project that way. Your calligraphy artwork could be silkscreened, or made into a repeating pattern and digitally printed; these techniques will vary depending on the type of printer used.

My friend Angela Liguori at Studio Carta makes beautiful ribbons. Her factory in Italy had certain artwork requirements, so I provided the original artwork on smooth-finish Bristol board. The factory printed the alphabet ribbon with white opaque ink on black fabric, and the result was stunning.

You can also visit spoonflower.com, an online custom-printing company, to easily transfer your image onto fabric, wallpaper, gift wrap, and more.

Wood

When writing on wood, there are different effects that you can achieve depending on the woodgrain. A pointed nib on a soft wood such as balsa or pine will cause a feathering effect. A slice of hardwood like birch or walnut may give you a smoother surface. Here I used walnut ink and a pointed pen on a slice from a birch tree branch.

Ceramic & Glass

There are many applications to transfer your work onto functional and beautiful pieces such as ceramics. There are decals that you can have made and fired and you can also achieve a calligraphic look at a paint-your-own-pottery studio. On page 105 I share a project to create a custom piece right in your own kitchen!

Creating is a gift

Everyone possesses the gift of calligraphy, and like everything else it needs to be nurtured through practice and patience. When playing with colors and materials, you will make mistakes—and in my experience, some of my best work came out of these mistakes. Allow yourself to be open to the creative process, and through it you will find growth—personally, emotionally, and artistically.

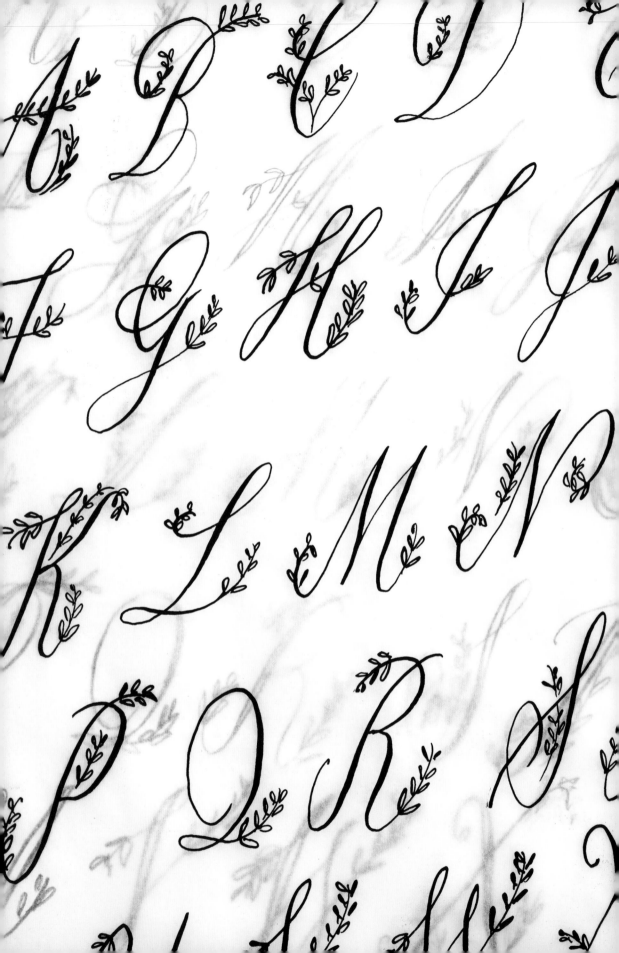

CHAPTER 5

Projects

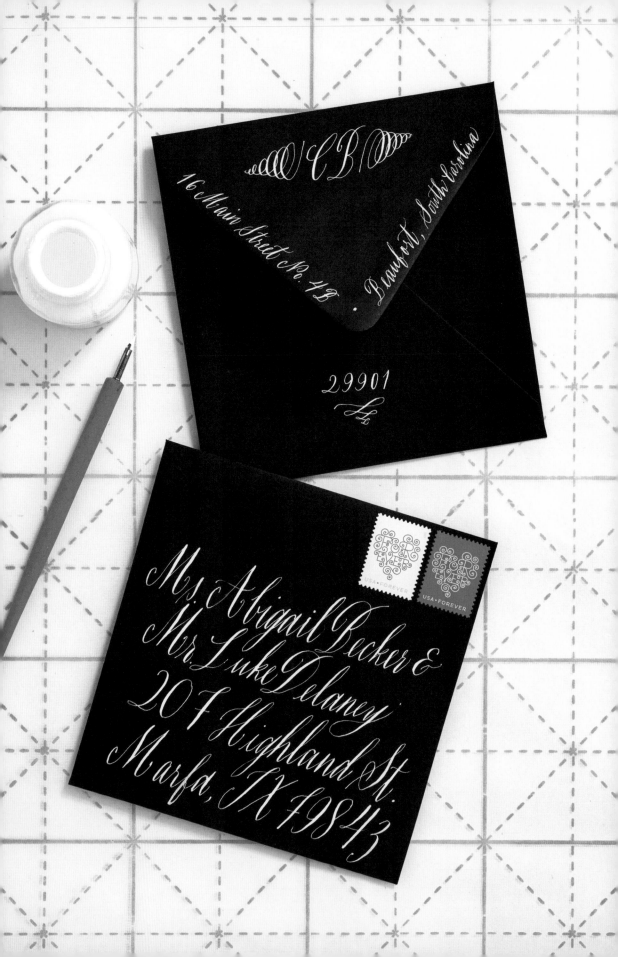

Elevated Envelopes

When I was a beginner at calligraphy, I offered to address envelopes for any friends who were throwing a party or getting married. Needless to say, I got a lot of practice—fifty guests means fifty opportunities to play with calligraphy. But don't wait for a formal event to try calligraphy on your correspondence. Everyone loves and appreciates the look of a hand-addressed envelope. It's such a bright spot amid the dreary daily mail!

When I address an envelope by hand, I usually write the recipient's address without guide lines, because I prefer the look of naturally staggered lines to perfectly centered ones. On the square envelopes shown here, I used the edges of the back flap as my visual guide for writing out the return address. When I realized that I had run out of room for the zip code, rather than waste the envelope and start over, I added the zip as an extra decorative element just under the pointed edge of the flap.

Before you proceed, test the ink on the type of envelope that you will use, especially if you are using a type of paper or ink mixture that you are not familiar with.

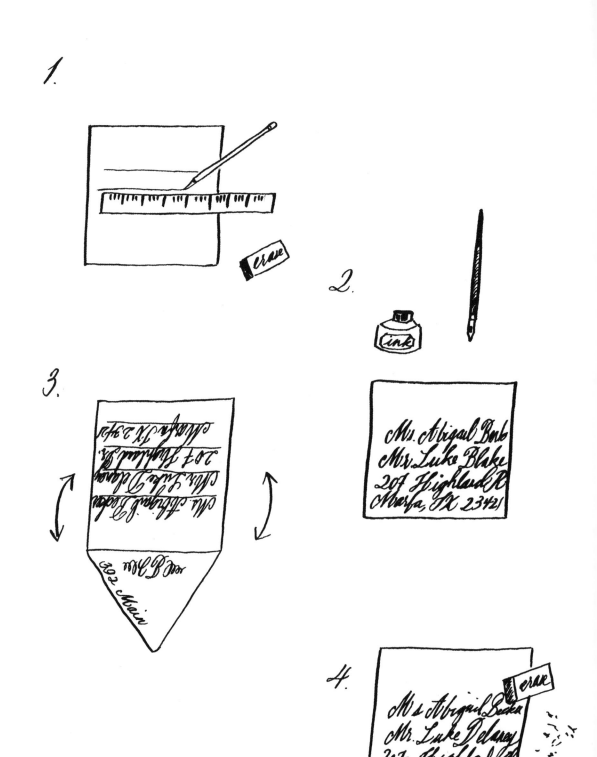

Instructions

SKILL LEVEL

EASY

MATERIALS

Ruler

Pencil

Envelopes

Pointed pen

Ink

Eraser

1 If you'd like guide lines, use a ruler and pencil to lightly draw lines on an envelope.

2 Using pointed pen and ink, write the recipient's name and address on the front of the envelope, leaving room for postage..

3 While the front is drying, open the envelope flap so you can write the return address on the back flap. Allow the ink to dry completely.

4 Erase any visible pencil marks. Be sure to use a white eraser on white or light paper, and a black eraser on black or dark paper.

VARIATIONS

See the next spread for lots of design ideas for making standard envelopes outstanding. For example, you could:

· Write the return address along the short side of the envelope

· Use large brush calligraphy to fill the entire front of the envelope

· Mix roman and script lettering

· Write the address on vintage labels

· Use window envelopes for a peekaboo effect

· Use brightly colored inks and envelopes

· Fill the blank space around the address with figure-eight flourishes

· Place the addressed envelope inside a translucent outer envelope

· Try walnut and metallic inks

· Write a secret message on the envelope liner, under the flap

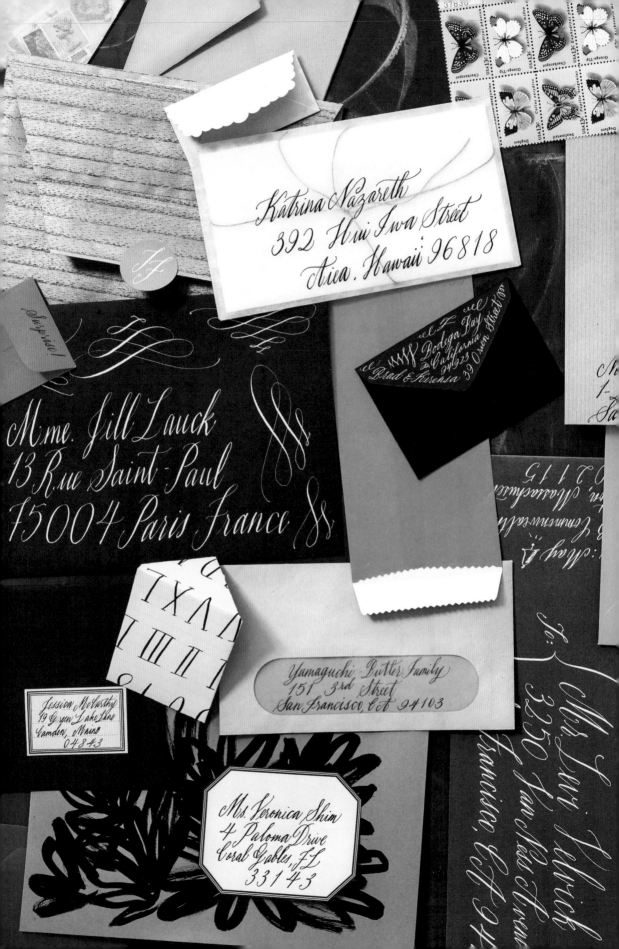

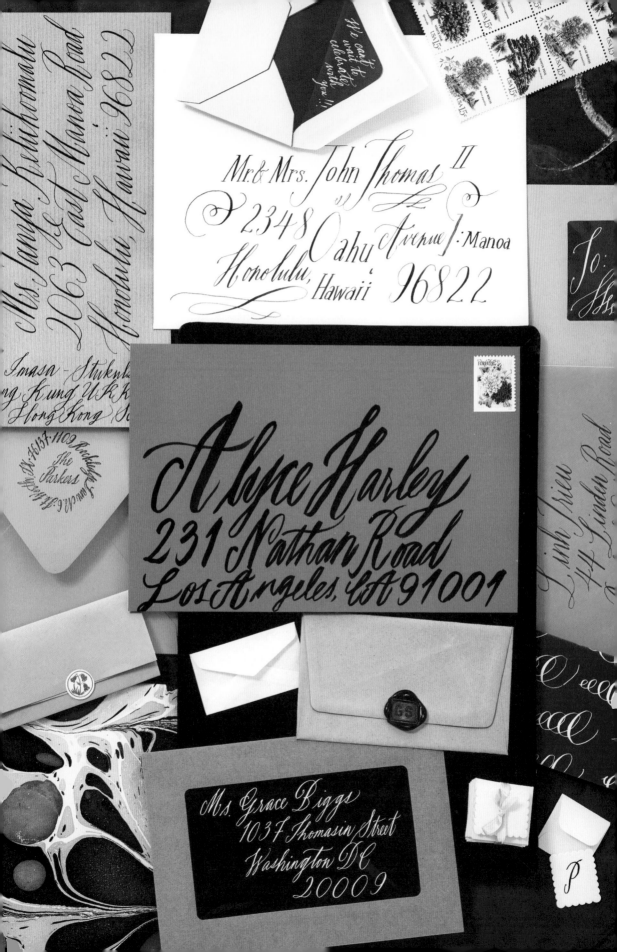

Desiderata

Go placidly amid the noise and haste, and remember what peace there may be in silence. As far as possible without surrender be on good terms with all persons. Speak your truth quietly and clearly; and listen to others, even the dull and the ignorant, they too have their story. Avoid loud and aggressive persons, they are vexations to the spirit. If you compare yourself with others, you may become vain and bitter; for always there will be greater and lesser persons than yourself. Enjoy your achievements as well as your plans. Keep interested in your own career, however humble; it is a real possession in the changing fortunes of time. Exercise caution in your business affairs; for the world is full of trickery. But let this not blind you to what virtue there is; many persons strive for high ideals; and everywhere life is full of heroism. Be yourself. Especially, do not feign affection. Neither be cynical about love; for in the face of all aridity and disenchantment it is as perennial as the grass. Take kindly the counsel of the years, gracefully surrendering the things of youth. Nurture strength of spirit to shield you in sudden misfortune. But do not distress yourself with dark imaginings. Many fears are born of fatigue and loneliness. Beyond a wholesome discipline, be gentle with yourself. You are a child of the universe, no less than the trees and the stars; you have a right to be here. And whether or not it is clear to you, no doubt the universe is unfolding as it should. Therefore be at peace with God, whatever you conceive Him to be, and whatever your labors and aspirations, in the noisy confusion of life keep peace with your soul. With all its sham, drudgery, and broken dreams, it is still a beautiful world. Be cheerful. Strive to be happy. Max Ehrmann

Framed Quote

Inspirational thoughts displayed throughout your home proves that an original work of art does not need to cost a lot. For a project like this, there are so many things to consider, such as the amount of text that you will be writing, where it will be displayed, how it will be framed, what type and color of paper and what type of ink to use. Here is a chance to use a special paper that you have been wanting to try out. I created this with black ink on smooth cream-colored drawing paper, but I think it could look spectacular with white ink on black paper too.

I chose to write *Desiderata,* written by Max Ehrman, because it was a favorite quote of a friend. When I finally had a chance to read it, the words really spoke to me too. When I was considering the design for this quote, I thought that it was important to have a strong visual balance between the actual writing and the white space around the words. There was a lot of text involved, so I knew it would work for my design idea. When seen from far away, you recognize the shape, but upon closer examination you see that it is created with beautifully written words and when you are up close you realize that it is written by hand. I chose a simple black frame so as not to compete with the artwork.

Use this idea to make a very special gift for someone who has a favorite a poem or quote, or wedding vows. Be sure to create one for yourself as a reminder to always be inspired by beautiful and meaningful words.

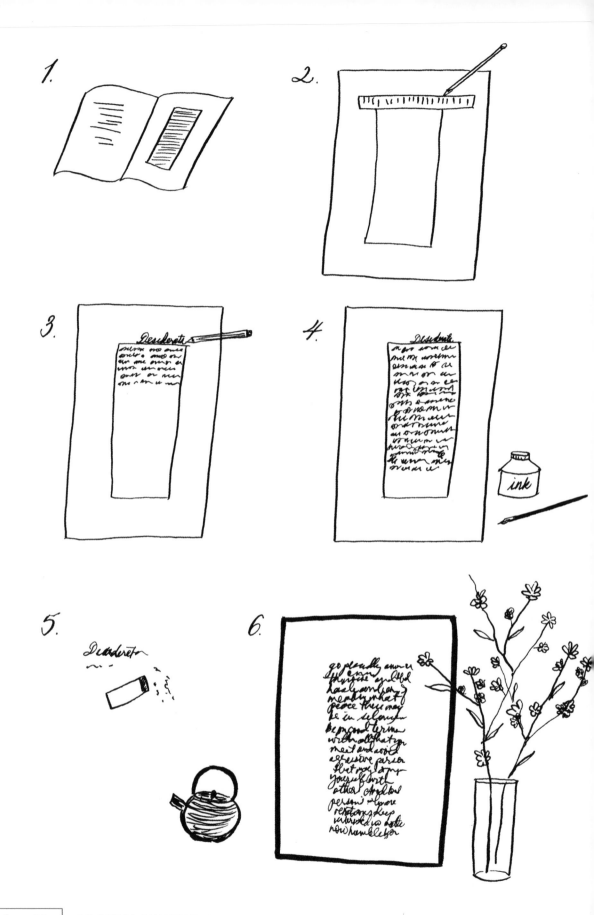

Instructions

SKILL LEVEL

INTERMEDIATE

MATERIALS

Practice paper

Pencil

Ruler

Drawing paper,
20 by 24 inches

Eraser

Pointed pen

Sumi ink

1 Consider the amount of text involved in the piece and then, with practice paper and a pencil, sketch out possible designs. Play with letter size and spacing as you write the entire quote in the shape to see how the words will fit. Choose your final design.

2 Using a ruler and pencil, draw a rectangle shape on the drawing paper.

3 Write out the quote lightly in pencil, erasing and starting over as necessary.

4 Once the size and spacing are final, ink over the pencil with your pointed pen. This is the trickiest part, so stay relaxed and be open to anything that may slow down your work. You may end up with a few versions of the same piece until you nail it.

5 Erase any visible pencil lines after allowing the ink to dry completely.

6 Frame or display as desired.

Make it happen

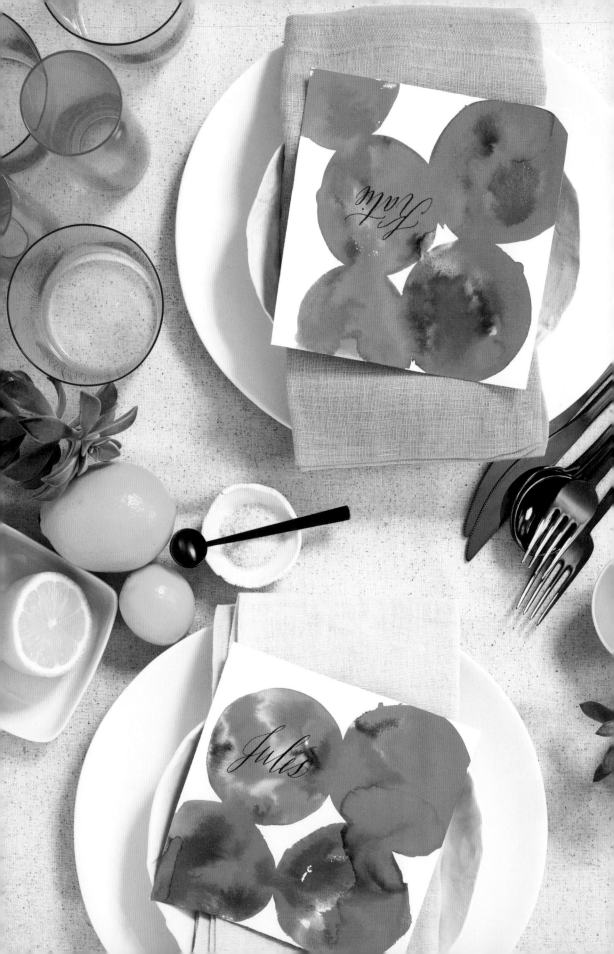

Watercolor Placecards

Watercolor placecards are a fun and unique way to add vibrant color to a dinner party or other gathering. Since watercolors are meant to be imperfect and fluid, even if you have never painted before, the results will amaze your guests—each one is a work of art that your guests can take home.

Watercolor paints have a beautiful flowing effect, and it's wonderful to watch how the colors blend together, sometimes unintentionally. In this project I chose to work with liquid watercolors, which come in bottles—some have droppers included—but feel free to experiment with watercolors in pans, too. The paints will dry transparent, which highlights the texture of the paper. This project's process is experimental and you may have feelings of uncertainty. I had them too! Keep going. It's going to look beautiful. Once you see the gorgeous results, you can use this watercolor technique for other projects such as tags and greeting cards.

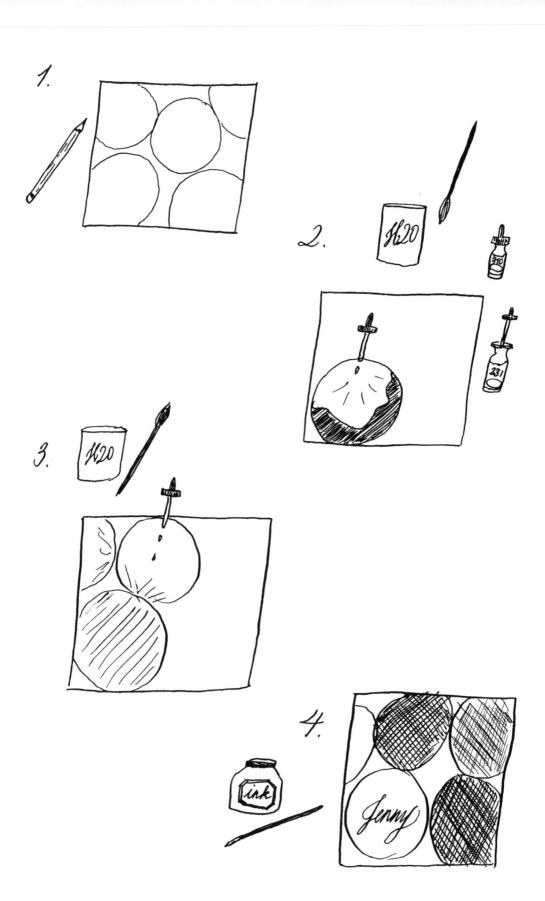

1.

2.

3.

4.

Instructions

SKILL LEVEL

INTERMEDIATE

MATERIALS

Sketchbook

Pencil

Pad of cold press
watercolor paper,
6 by 6 inches

Round watercolor brush,
size 4 or 6

2 containers of water

Dr. Ph. Martin's Radiant
Concentrated Water Colors

Pointed pen with
Nikko G nib

Black ink

1 In a sketchbook and using a pencil, sketch out a rough idea of how big you would like to make each color circle. Each circle should have an imperfect round shape and should feel organic in the placement. Also, determine your color palette. For the example here I used Tropic Pink, Ice Pink, Vermillion, Magenta, and Black. Once you've determined what you like, draw circles on your final cards.

2 When you're ready to begin painting, dip a brush into clean water and paint your first circular shape. Drop in the first paint color using the dropper. You will notice that the color immediately spreads out, moving into the areas that you brushed with water. Add one drop of color at a time until the circle is filled with color.

3 Using the same technique, paint your next circle so that it just barely touches the first circle. By placing another circle close enough to the first circle, when you drop the second color the two will blend together. Continue this process until you have filled the paper with the designs and colors that you have chosen

4 After each placecard has dried completely, use pointed pen and ink to write out each guest's name. Each card will have a different place where your calligraphy will look the best. Set the cards on a prepared clean surface to dry.

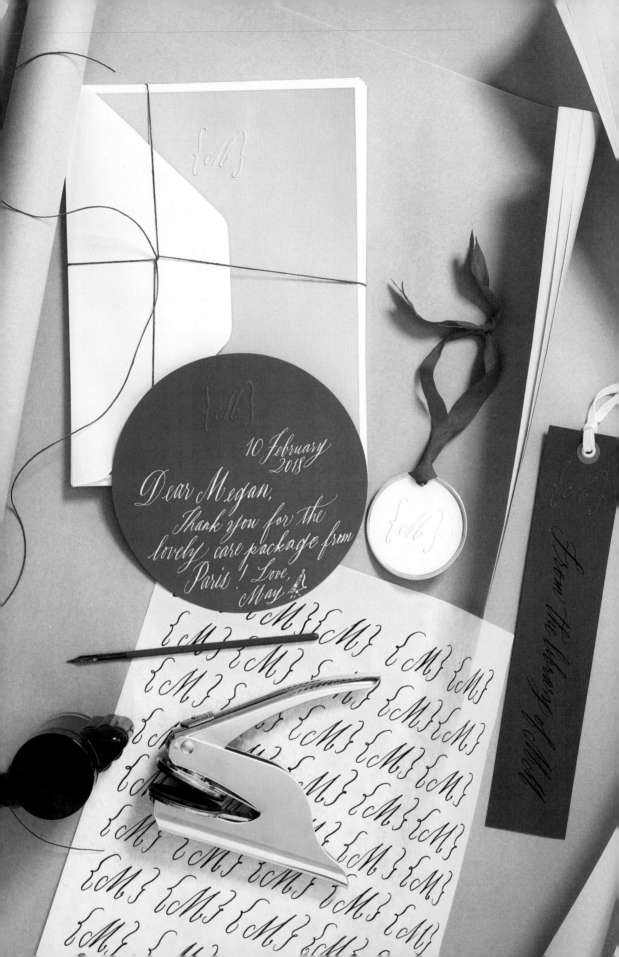

Embossed Stationery

An embosser is a clamping tool with a metal die that creates a crisp, raised impression when pressed onto paper. Embossing gives paper a tactile quality with an elegant yet subtle detail that delivers a big impact. A while back I had an embosser made with my initial *M* on it, thinking I would use it just to make some quick, personalized stationery for myself. Seeing my own handwriting as raised lettering felt so fancy and professional! And I ended up embossing everything in sight—paper napkins for parties, the first page of my books, paper key tags, labels, sketchbook covers, my art prints (instead of a written signature) . . . *everything*.

My embossing obsession gave me the idea of a gift to make for the person who seems to have everything: an embossed stationery set. In this project, you'll pen a single letterform, have it made into an embosser, then use the embosser to create a set of personalized stationery. You can then gift the stationery set along with the custom embosser so the recipient can leave their mark on anything they desire, too. It's the gift that keeps on giving!

See Sources (page 210) to find companies that make custom embossers. Be sure to check their production times (often around three weeks) so you have enough time.

1.

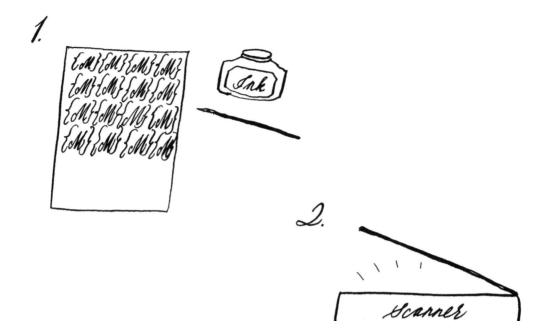

2.

Scanner

3.

order online

4.

Embosser

5.

{CM}

Instructions

SKILL LEVEL

E A S Y

MATERIALS

Pointed pen

Black ink

Practice paper

Scanner

Computer

25 notecards

25 envelopes

Waxed twine or ribbon

1 With pointed pen and ink, practice and then write the initial that you would like to make into an embosser. Common choices include first and last initials; first, middle, and last initials; or just a single initial. Ideally the letterform will not have any breaks or skips. For the embosser shown on page 94, I wrote out the letter *M* within curly brackets to fit a circular embossing die, approximately 1⅝ inches around.

2 Scan your final artwork and save it as a PDF.

3 Order the custom embosser from an online stationery retailer such as Fred Lake, CustomEmbossers.com, or TheStampMaker.com. Specify to the maker that you plan to use the die on thick paper and that it will be stamped from the top of the embosser.

4 When your custom embosser arrives, use it to emboss the note cards. Be sure to place the initial off-center or in a corner so there is space to write on the card.

5 Bundle the stamped notecards and envelopes together with twine or ribbon and include the embosser in your gift package.

Give often

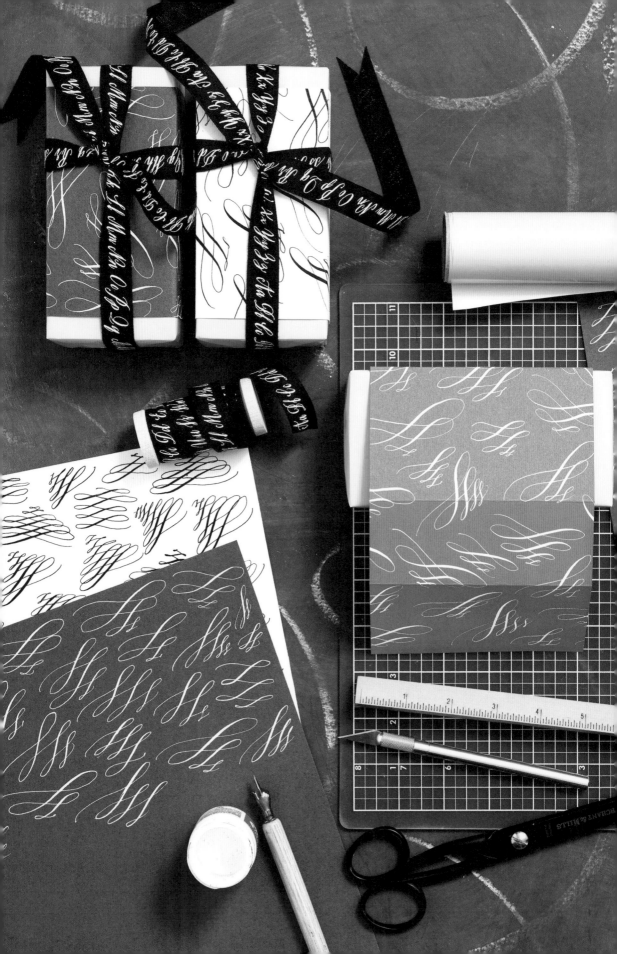

Gift Wrapping with Calligraphy

Wrapping gifts with calligraphed paper is a lovely way to enhance presentation—and an excellent way to incorporate other projects in this book, such as gift tags and labels. You can even turn your practice sheets into wrapping paper, which has the added bonus of reusing paper that you would normally discard. For example, if you used a whole sheet of paper to practice the letter A, use that to wrap a gift for someone whose name begins with A. For wrapping large gifts, practice on big pieces of charcoal paper, available in a wide variety of colors. (Sumi papers are also available in large sheets to practice your brush calligraphy, if you opt to lay down the pen and use a brush.) Large rolls of kraft paper, black paper, and butcher paper are perfect for wrapping, too. Try writing in various sizes for contrast, and in different directions on the paper—diagonally, vertically, curved . . . anything goes.

To get your creative juices flowing, try filling up a page with your warm-ups first. This creates a nice pattern and it may lead to other ideas. Try writing one of the lists mentioned on page 54. Or practice the Blotted Line Technique (page 73) and fill a page with blotted letters. Look in books for photos of flowers or vintage botanical illustrations as inspiration, and try to draw them. (The rules of perfectly imperfect calligraphy apply to drawings as well!) With a page of practice warm-ups, I created a bellyband that wrapped around a box wrapped in plain pink paper (see page viii). On pages 102–103 are some of my favorite ideas.

1.

2.

3.

4.

5.

Instructions

SKILL LEVEL

EASY

MATERIALS

Pointed pen

Ink

Colored paper large enough
to make a band around
your gift

Wrapping paper

Scissors or X-Acto knife

Ruler

Double-sided tape

Assorted ribbons or twine

1 Using pointed pen and ink, fill an entire page of paper with practice strokes, flourishes, alphabets, or written quotations. Repeat the same text many times in different orientations to create a pattern. Let dry.

2 Using wrapping paper, wrap your gift.

3 Using scissors, trim your piece of calligraphy patterned paper into a strip long and wide enough to wrap around the gift but still show the edges of the wrapping paper. This is the bellyband.

4 Adhere the bellyband to the wrapped gift with double-sided tape on the underside, overlapping the band on the bottom of the gift.

5 Finish with ribbons or twine.

VARIATIONS

Your calligraphy doesn't have to be just a bellyband. See the next spread for lots of design ideas for making unique wrapping paper. For example:

· Large-scale brush lettering

· An entire page of one letter

· Ink splatters and spills

· Mistake pages

· Color tests

· Discarded sketches

· Writing in different directions

· Write directly on a wooden box

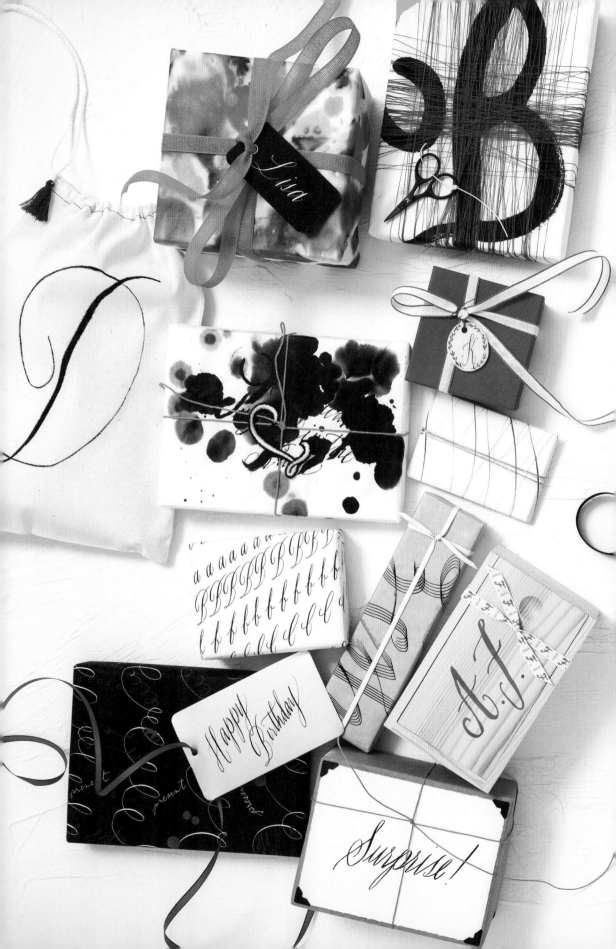

Pictured here are gifts wrapped with paper and items lying around the studio. I used practice papers, labels, muslin bags, old drawings, and ink experiments.

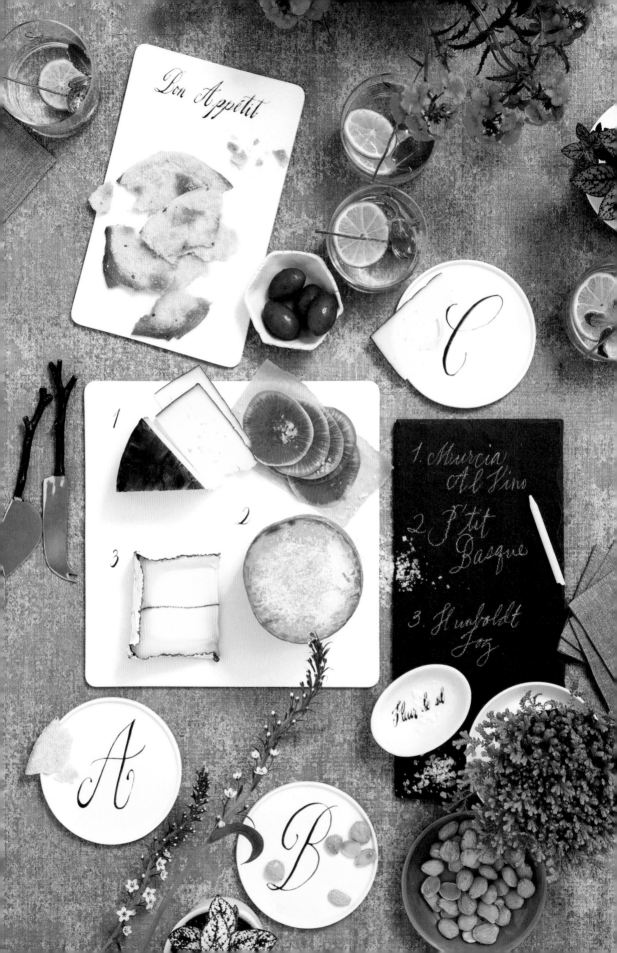

Bon Appétit

C

1

2

3

1. Murcia Al Vino

2. P'tit Basque

3. Humboldt Fog

A

B

Fleur de sel

Calligraphy on Ceramics

You don't have to be a potter or invest in expensive materials to create custom dishware. With a specific type of paint and your kitchen oven, you can transform plain serving trays, glassware, and more into custom designed, calligraphed dinnerware.

For this project, I chose to do a numbered platter and coordinated drinking glasses. I use the numbered platter to beautifully serve cheese or charcuterie along with a corresponding menu or card, so guests can easily identify the items. And numbered glasses are a stylish way for people to keep track of their drinks at a party.

A few technical tips to keep in mind: This technique works best on flat surfaces, such as straight-sided glasses so your ink doesn't run, and also on smooth surfaces so your nib doesn't catch. Keep your design simple so when you're handling a three-dimensional object such as a cup, so you don't have to worry about smearing your work. And the beauty of these materials is they're very forgiving—you can practice and wipe away your design with a paper towel as many times as you need, before you decide it's final and ready to make permanent by baking it in the oven.

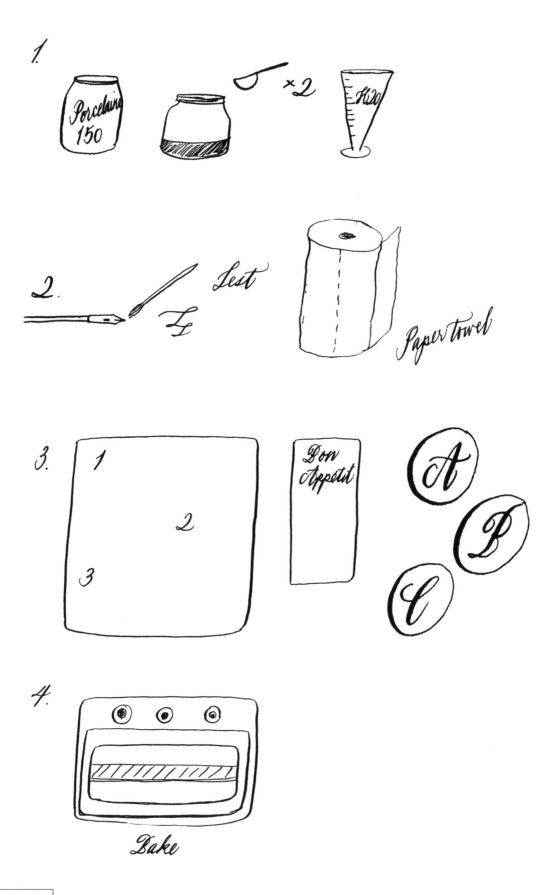

1.

Porcelaine 150 ×2 *H₂0*

2. *Test* *Paper towel*

3. 1 2 3 *Bon Appétit* *A* *B* *C*

4. *Bake*

Instructions

SKILL LEVEL

ADVANCED

MATERIALS

Measuring spoons

Pébéo Porcelaine 150 paint, black

Small glass jar with lid

Distilled water

Paintbrush

Pointed pen

Flat ceramic dish or serving platter

Moist paper towel

NOTE

This project takes 2 days.

1 Pour roughly 2 tablespoons of paint into a jar. Add distilled water 1 teaspoon at a time and mix with a paintbrush until the consistency is thin enough to flow through your nib.

2 Paint this mixture onto your nib (instead of dipping your nib directly into the paint, which can clog your nib), and then make some practice marks on your ceramic platter. Try some warm-up strokes (see page 34) such as figure eights; you have the right consistency and method when you achieve the same thick and thin lines that you do on paper. Use a moistened paper towel to wipe away your practice marks.

3 Finalize your design on the platter or dish. Allow the paint to dry for 24 hours.

4 Follow the manufacturer's baking instructions as printed on the paint bottle to make your design permanent.

VARIATION

· Create personalized presents or hostess gifts by writing a monogram, wedding date, birthdate, or word, such as *Fromage*

Savor special moments

Matchbox Countdown

The holidays are a time to create family traditions and memories to cherish. In this project, you'll write down special activities in calligraphy and fold them as messages inside miniature matchboxes. Then, every day you open a box and have a fun and festive activity to help celebrate the approaching holiday with family and friends. Creative messages go into each box—for example, leading up to Christmas I would write things like "Let's go ice skating!" and "Let's watch our favorite movies together!" Kids love wintry treats and themed projects: "Time to make some hot cocoa!" "Will you make paper snowflakes with me?"

Holidays aren't the only time for this matchbox project. Make it for a bride to count down the days leading up to her wedding, writing wishes or encouraging blessings to support her in anticipation of her special day. Or gift it to friends who are expecting a baby, filling each box with a humorous tip or piece of sage parenting advice.

Matchboxes are inexpensive, and are easy to find in twelve-packs at the hardware store and without matches at art supply stores. I've made them in a bright color combination for my kids, but feel free to incorporate your favorite palette.

1.

2.

3.

4.

5.

×25

6.

Let's go ice skating!

7.

Fold

Fold

25

Let's

8.

Instructions

SKILL LEVEL

EASY

MATERIALS

25 empty matchboxes

Ruler

Pencil

Scissors

6 sheets smooth 8½ by 11-inch paper, assorted colors

Pointed pen

Ink, assorted colors

Double-sided tape

Glitter and other embellishments

1 Using a matchbox as your size guide, measure and cut the colored paper into 25 long strips that will wrap around the outside of the matchbox with a little overlap.

2 With pointed pen and ink, using a few different ink colors, write one number—1 to 25—on each paper strip. Place the numbers in or near the center of the area that will be on the matchbox front. Don't worry about perfection here—as long as the numbers are somewhere in the matchbox-front vicinity, they will look great. You can orient the numbers in portrait or landscape format, or a variation, and embellish them with stars, lines, swirls, or borders if you'd like. Allow the ink to dry completely.

3 Wrap a numbered strip around a matchbox, using your fingers to crease each fold aligned with the edges of the box. Use double-sided tape to adhere the strip to the matchbox. Repeat for the remaining 24 matchboxes.

4 Slide out the tray from a matchbox and measure the inside. This is how large each inserted paper message can be when folded up.

5 With those measurements as your guide, use a ruler and pencil to make 25 rectangles on colored paper and cut them out. You'll likely want to double or triple the width measurement, so you can write longer messages.

6 With pointed pen and ink, write one activity on each piece of paper. Allow the ink to dry completely.

7 Fold each message and tuck it inside a matchbox.

8 If you wish, fill the boxes with glitter, confetti, sweets, or trinkets.

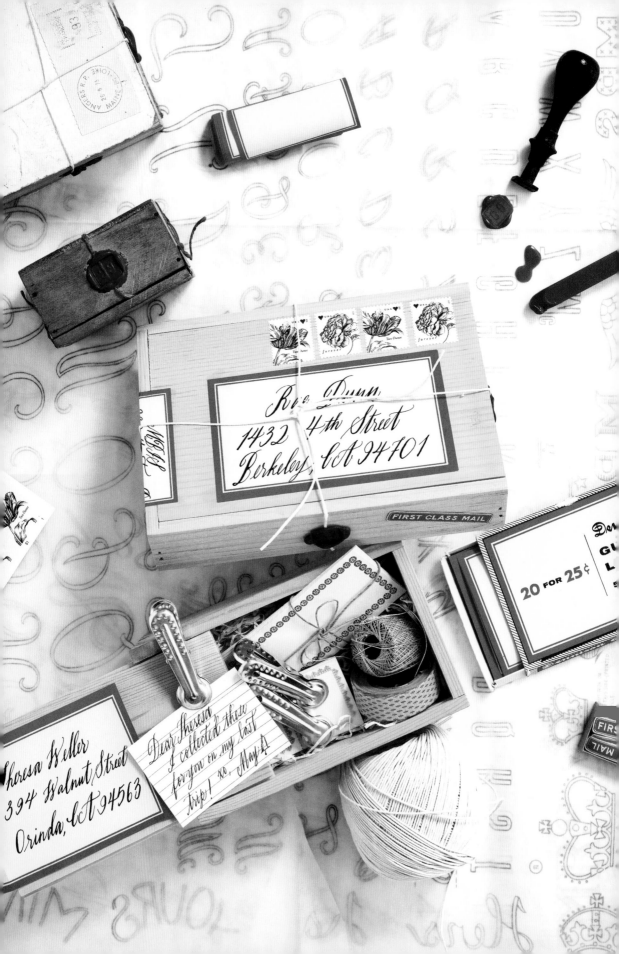

Ros Dunn
1432 4th Street
Berkeley, CA 94701

FIRST CLASS MAIL

20 FOR 25¢

Theresa Weller
394 Walnut Street
Orinda, CA 94563

Dear Theresa,
I collected these
for you on my last
trip! xo, May 4

Wooden Parcel Mail Art

I adore anything packaged in a wooden box—a work of art in and of itself—and one that has been sent through the mail sparks even more joy for me. One of my favorite treasures found at a Paris flea market is a wooden box that originally was used to send jewelry or patents. To indicate the authenticity and that the parcel had not been tampered with, the box was tied with string, then secured with a red wax seal over a handwritten label.

A US Postal Service clerk once told me that "if it has an address label, it can be mailed." To test this statement, I sent a thank-you letter in a small box, similar to the one pictured here, to a friend. When she received it, she called right away with delight to say that it wasn't a just any letter, but "an experience" to receive something special like that in the mail. Since then I've used the wooden-box mailer for wedding invitations and birthday cards. With this project, you too can send a boxed thank-you note or birthday greeting, all in the name of mail art.

1. *Labels*

Gold twine

Washi Tape

Vintage Clips

Dear Theresa Here are some goodies for you

goodies

Open

2.

To: Rae Dunn #32 4th Street Berkeley, CA

From: M.B. Oakland, CA 94602

3.

Closed

4.

5. *sealing wax* *wax*

candle

wax drop *seal*

6.

LOVE USA 20¢

Vintage

Instructions

SKILL LEVEL

INTERMEDIATE

MATERIALS

Unfinished wooden
box with sliding top

Shredded paper

Assorted vintage or
new labels

Pointed pen with
Nikko G nib

Sumi ink

Twine or string

Sealing wax

Candle

Matches

Wax seal

Spoon

Stamps

1 Place a few small items and a handwritten note in a wooden box, then fill it with shredded paper and close.

2 On a label, use pointed pen and sumi ink to write the recipient's address and your return address. Use two separate labels if necessary for space. Allow the ink to dry completely.

3 Affix the address labels to the top of the box, leaving space to seal one edge of the sliding top.

4 Use your return address label or another label to lock the sliding top in place. Additional decorative vintage labels—like "Parcel Post" or "First Class"—would be lovely on the piece, as well.

5 Tie some twine around your box and then adhere to the box on four sides with sealing wax. To do so, break a tiny bit of wax into an old spoon. Melt it over the flame of a candle, pour a bit of wax, about the size of a quarter, over the string on one side of the box, and press with the seal. Repeat on all sides. Note that working with wax seals can be tricky, so you may want to practice a few times before working on the final box. Keep in mind they may fall off in transit—but this just adds more charm to your parcel.

6 Take your wooden parcel to the post office to find out the postage rate. Then source a few vintage stamps online, if desired, or browse the selection of current stamps that are available at your post office. Use actual stamps, not a machine-printed sticker, for more old-world charm.

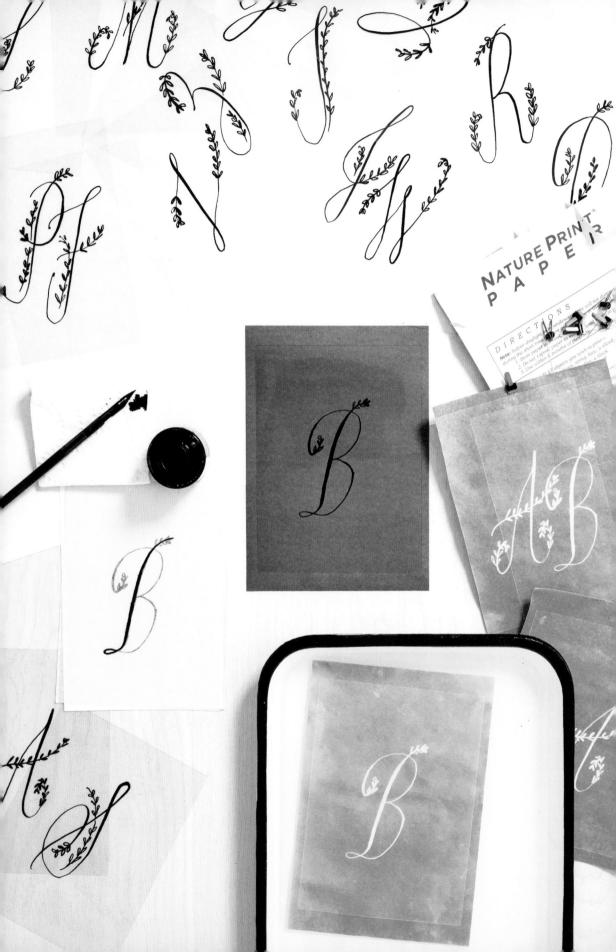

Cyanotype Alphabet

In 1843, English botanist Anna Atkins created a book of sun prints from algae. The process of sun printing is known as cyanotype, a photographic process using paper treated with a chemical mix to make it photosensitive. When exposed to UV light, the paper turns a rich, dark blue color; whatever is not exposed remains white. Cyanotype printing is most associated with plants such as ferns and seaweed, but for this project you'll create a lovely set of botanical letters that you can bundle or frame as a gift for a baby, a gardener, or anyone who appreciates art and nature. You can also layer your letters to create monograms like the ones shown on the opposite page. Keep in mind that creating images this way is an imperfect process!

Up until now, you have worked mostly with pointed pen and ink on paper. Here you will write calligraphic marks directly onto acetate with an ink that dries to a glossy finish—perfect for drawing on acetate. And to make things simple, use prepared cyanotype paper. Once you're comfortable with the process, you can find the solution in powder form and, following the directions on the package, use it for future projects to print on other surfaces such as fabric or larger sheets of paper.

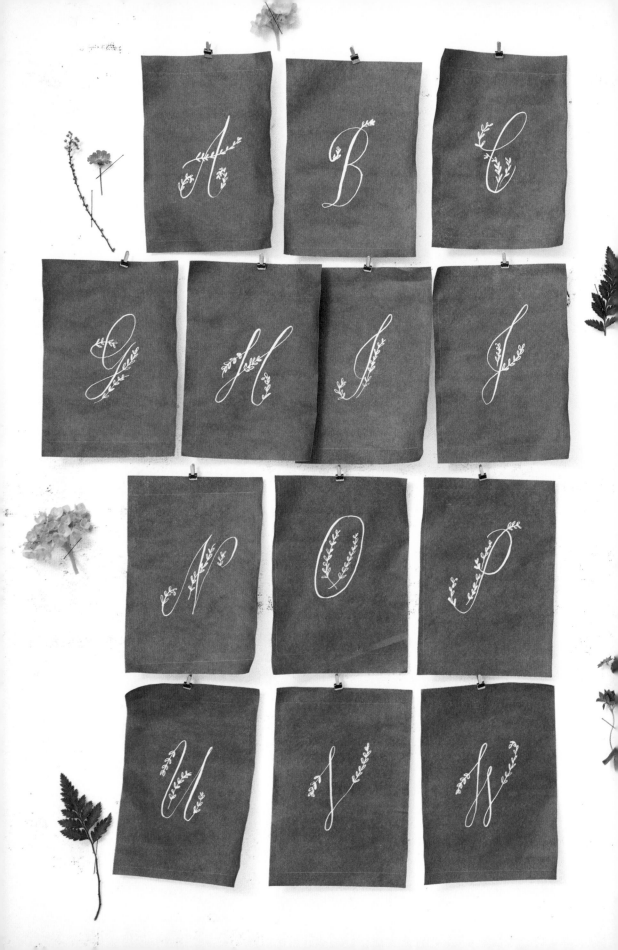

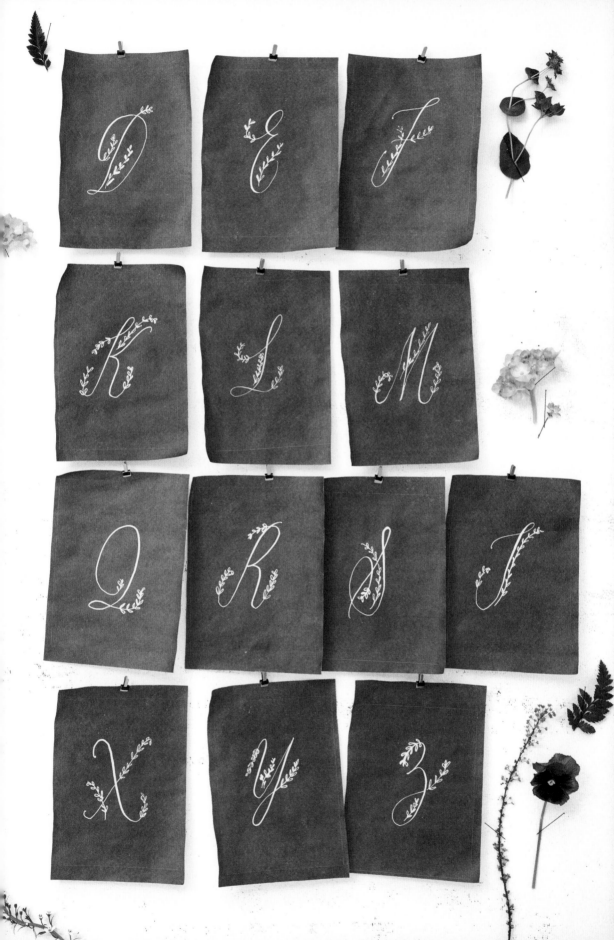

1.

12"

9"

2.

3.

Scratch

4.

6"

4½'

hicas
ink

5.

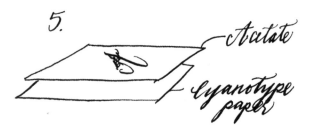

Acetate

cyanotype
paper

6.

2minutes!

7.

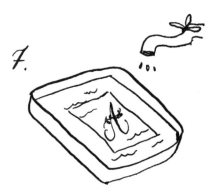

Instructions

SKILL LEVEL

INTERMEDIATE

MATERIALS

Acetate pad, 9 by 12 inches

Paper cutter or scissors

Sketchbook

Pencil

Pointed pen

Dr. Ph. Martin's Black Star Hi-Carb India ink

1 pack NaturePrint cyanotype paper, 5 by 7 inches

Towel or drop cloth

NOTE

It takes 1 to 2 days to complete all 26 letters. Once dry, you can iron the prints between two sheets of paper on a low heat setting to flatten them.

1 Cut eight sheets of acetate into 4½ by 6-inch pieces. Set aside.

2 In your sketchbook, pencil some different design elements to add to your script calligraphy. I added some leaves but feel free to play around a little here. Note that the letters needed for this project will be slightly larger than what you are used to. (See the template on page 204 for the alphabet that I created.)

3 If this is your first time using a pointed pen with this type of ink and smooth surface, practice on a spare sheet of acetate. This ink can be tricky. Note that if you have lotion on your hands, it may affect the way the ink sits on the acetate surface.

4 Draw one letter of the alphabet directly onto each cut acetate sheet. Since you can see through the acetate, you can lay your sheet over your sketches as a reference. Try not to trace them—this can make your lines wobbly. Allow the ink to dry completely on a flat surface. Do not stack the sheets.

5 Remove some cyanotype paper from its light-blocking package. Working with one or two sheets at a time, lay down a piece of paper, and then place an acetate sheet with your botanical letter on top of it. Remember that the paper is light sensitive, so work quickly and away from direct sunlight. Consider making a trial print to test the process.

6 Following the directions on the package, expose your artwork to sunlight or a UV light source for a few minutes. Do not overexpose the paper, or it will appear faded.

7 Once you've exposed your artwork, rinse each acetate sheet with water and set aside to dry on an old towel or plastic drop cloth. Since the cyanotype paper is quite thin, it will likely wrinkle—but I think this adds to the charm of it all. Repeat the process for the entire alphabet.

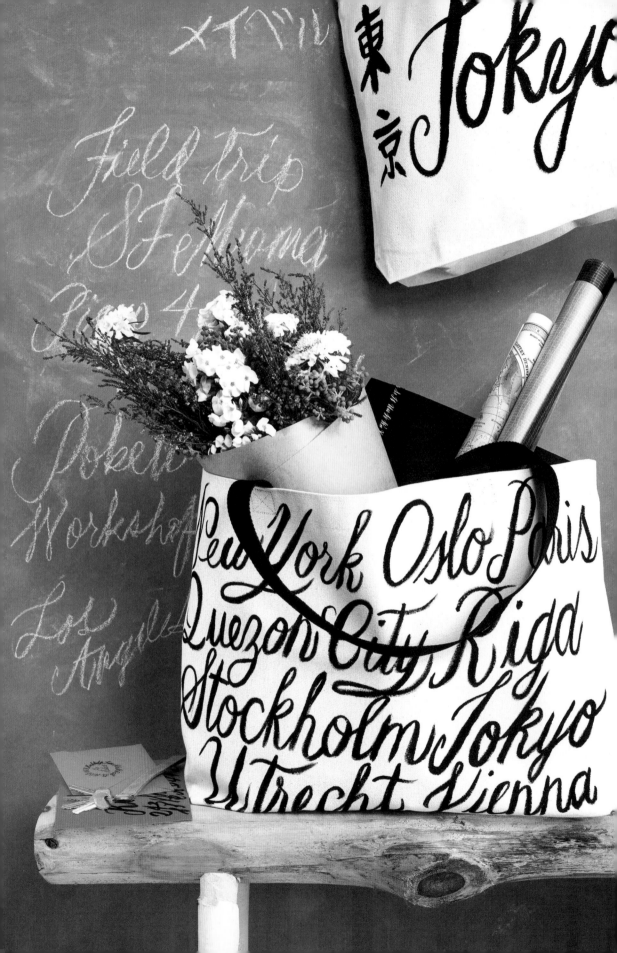

Brush Lettering Tote Bag

Reusable bags have become ever so popular, and tote bags with company logos or decorative designs are everywhere. They are indispensable; we use them for nearly everything. So why not use them to display something artistic or philosophical? Express yourself!

With this project you can create your own tote and flaunt your own personal calligraphy style. These bags are bold, graphic, and unique—no two are ever alike—and fun to make with brush lettering. They make wonderful gifts!

The brush lettering style shown here has just the right amount of sophisticated quirk. I used the names of my favorite cities in bold painted letters, but use whatever calligraphy style and words appeal to you. To achieve opaque, matte black letters, use acrylic craft paint formulated to work on fabric; once this paint dries, it is essentially permanent. If you work with fabric paints, the color may not be as opaque and may require a second coat, and this could affect the fluidity and look of the strokes in your painted letters. Or if you prefer the look of dry brush strokes, by all means go with that—stick with what you like and have fun experimenting.

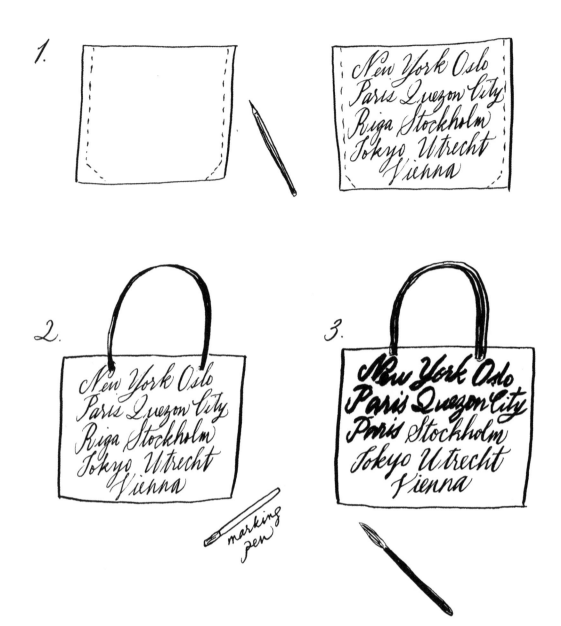

1.

2.

marking pen

3.

4.

60 min

5.

Instructions

MATERIALS

2 sheets newsprint paper, large enough to trace bag

Plain thick canvas tote bag, natural color

Pencil

Round paintbrush for acrylics, size 12 or 14

Dritz Disappearing Ink Marking Pen

Acrylic craft paint formulated to work on fabric, black

Water

Damp cloth

1 On each piece of the newsprint paper, trace the shape of your bag, and then sketch out some possible ideas in pencil. Once you have a final design, you can use your brush to practice painting it on the paper before doing it on the bag. Make adjustments to your design as necessary.

2 When you have finalized your design, use disappearing-ink marking pen to transfer the design onto the tote bag. Keep in mind that your painted letters will be a lot thicker than your marking pen lines.

3 Paint over the words that you wrote on the bag. To achieve the look of the letters that I created in the example, I used Martha Stewart Crafts Beetle Black Satin acrylic craft paint straight out of the bottle. If you prefer more fluid lines, thin your paint with water.

4 Allow your bag to dry for about an hour before working on the opposite side.

5 Use a damp cloth to remove any remaining disappearing ink marks.

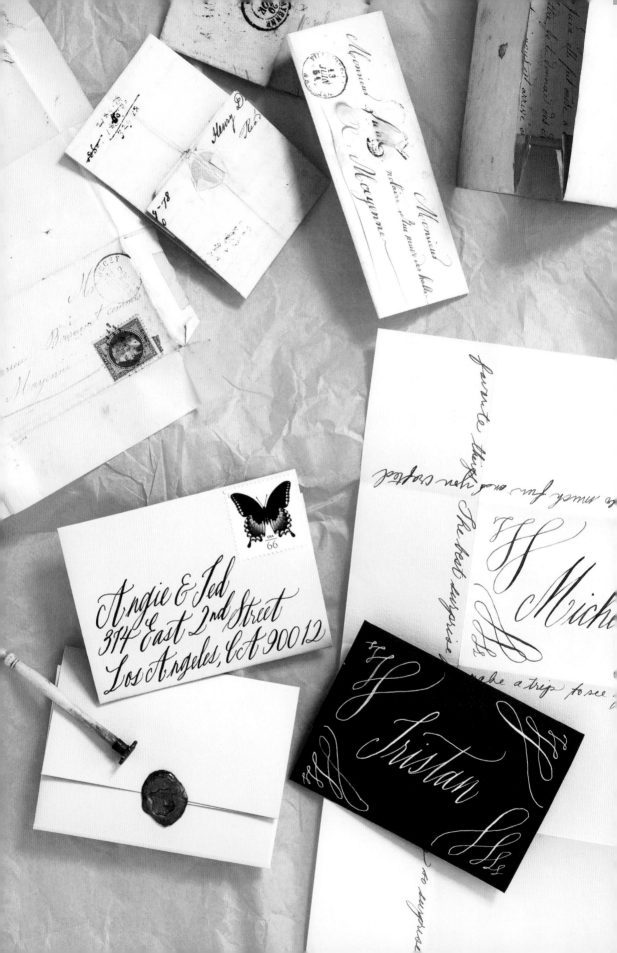

The Folded Letter

Before the common envelope was invented, letters were often written on one side of a piece of paper, which was then folded and sealed with wax. Paper was quite expensive then, so to save money the outside of the folded letter served as the envelope. In Jane Austen's time, letter writers needed to be economical with their paper usage too, so they would fill every nook and cranny of the page, often writing in multiple directions or around the paper's perimeter to make use of the entire sheet.

Even though envelopes are a dime a dozen these days, folding a letter to act as its own envelope is a special touch you can add to your correspondence. It calls attention to the letter, making the message itself a gift to receive.

To help prevent a folded letter's wax seal from coming off in the mail, look for "mail-friendly" sealing wax, or place your sealed letter in an outer envelope for mailing. Atelier Gargoyle makes a wonderful wax that is simple to use and comes in a wide assortment of colors. Of course, if you do not own a wax stamp, you could always seal your letter with washi tape (a natural-fiber, often prettily designed tape) or an adhesive label.

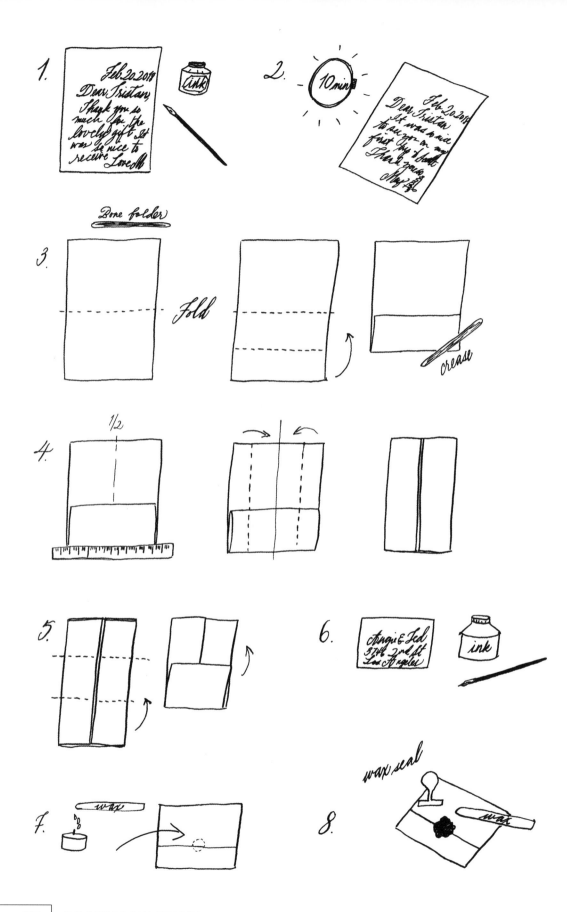

1. *Feb 20.2018 Dear Tristan, Thank you so much for the lovely gift. It was so nice to receive. Love M*

2. 10 min

3. Bone folder

 Fold

 crease

4. 1/2

5.

6. *Angie & Ted 3746 2nd flr Los Angeles* ink

7. wax

8. wax seal wax

Instructions

SKILL LEVEL

E A S Y

MATERIALS

Pointed pen

Ink

Text weight paper,
8½ by 11 inches

Bone folder

Ruler

Sealing wax

Tealight candle

Wax seal

1 Use pointed pen and ink to write your letter on the paper. Write in the standard top-to-bottom method, or get creative and write in multiple directions.

2 Allow the ink to dry completely, about 10 minutes.

3 Fold the letter in half vertically and make a crease with a bone folder. Open it up and fold the bottom edge up to meet the center crease, leave folded.

4 Measure the halfway point across the top with a ruler, and fold both right and left edges to the center point. As you go, crease your folds with the bone folder.

5 Fold the letter up from the bottom into three sections making the bottom two sections larger than the last to create a space for your seal. When the letter is folded, the side with the flap becomes the area that you will seal with wax.

6 Address the envelope on the other side and allow your ink to dry.

7 To seal the letter, melt the sealing wax over a flame (a tealight candle works well for this). You will know when there is enough melted wax for a seal because the wax will start to drip.

8 Drop a circle of wax about the size of a nickel over the folded edge of the letter. Working quickly before the wax starts to cool, press the seal into the melted wax.

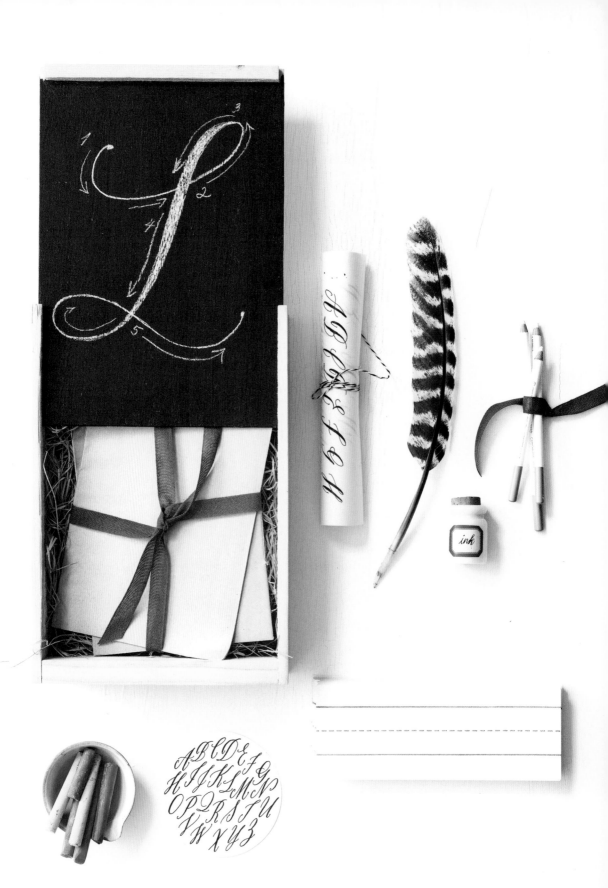

Calligraphy Kit for Kids

As more and more schools opt out of teaching cursive, I feel very fortunate that it's still being taught at my kids' public school. It has been proven that cursive handwriting develops fine motor skills and helps you retain information. And as I learned through my volunteer calligraphy teaching, children love writing with an actual feather quill, just like people did in the olden days. (In fact, you can easily incorporate this project into a history lesson about important documents that were written with a quill, such as the Declaration of Independence and the Bill of Rights.)

To share our love of handwriting, our favorite gift for kids' birthday parties is a custom handwriting kit. It's great to get your kids involved in the process of making them, too. Some kit items are lying around your house: notebooks, white and colored chalk . . . and why not include an alphabet that you have written during your own calligraphy practice?

For this project, find wooden boxes at your local art supply store or on Etsy. Use feathers found on hikes, or purchase these from the craft store, too. To create a calligraphy kit for an older child or an adult, simply replace the feather with a calligraphy pointed pen. Bonus: the recipient can reuse the box to store art supplies.

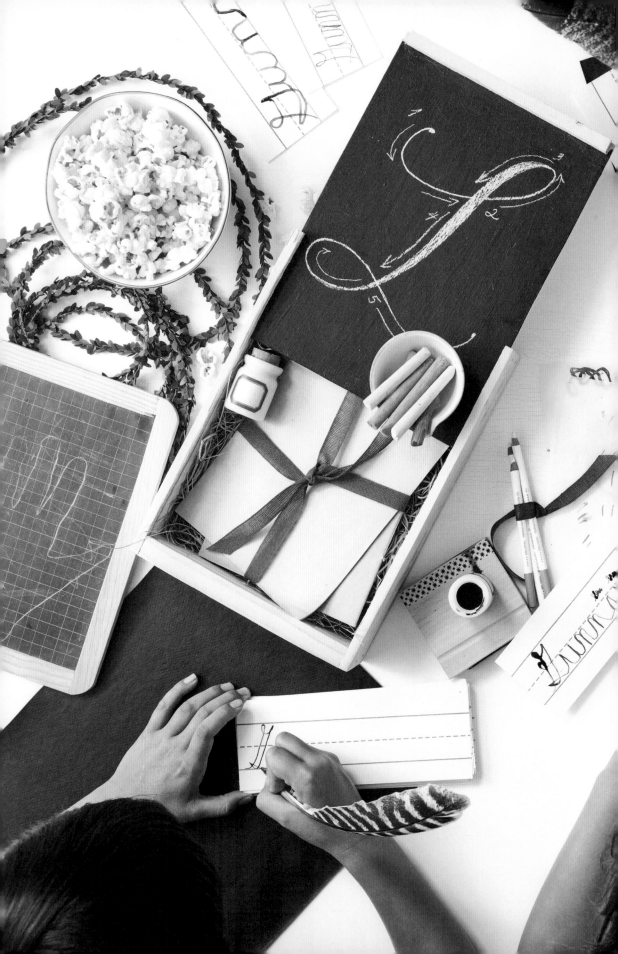

Our children having a fun play date and practicing their cursive writing with walnut ink and quills we made—truly a magical moment!

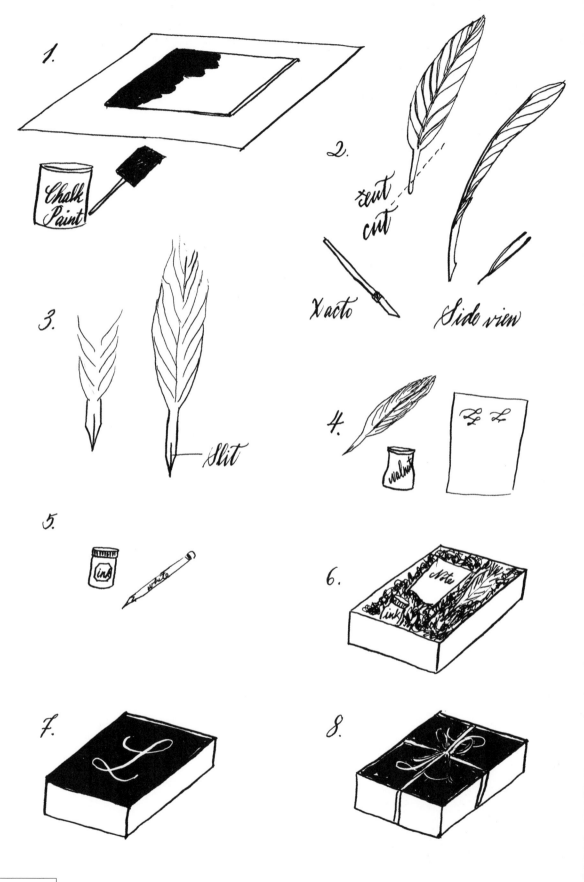

1.

Chalk Paint

2.

*cut
cut

Xacto

Side view

3.

Slit

4.

walnut

5.

ink

white

6.

Note

ink

7.

L

8.

Instructions

SKILL LEVEL

INTERMEDIATE

MATERIALS

Newspaper

Foam brush

Unfinished wooden box with sliding top, 11 by 9 by 2 inches

Chalkboard paint, black

Cutting mat

X-Acto or utility knife

Feather (turkey or goose work well)

Tweezers

Small jar of walnut ink

Label

Crinkle paper

Small blank-page notebook

Pieces of white and colored chalk

Wooden pointed pen with nib

Small card with calligraphed alphabet

Stabilo CarbOthello chalk-pastel pencil, white

Ribbon or linen twine

1 Cover your work surface with newspaper to protect it. Then, using a disposable foam brush, paint the box top with two coats of chalkboard paint, allowing the paint to dry between coats. Set aside and allow to dry.

2 On a cutting mat, using an X-Acto or utility knife, cut the bottom of the feather at a 45-degree angle. Tweeze out any feather parts that remain in the hollow shaft.

3 Cut a slit in the tip of the quill. This slit should look like the split in the tines in a metal nib.

4 Test to see if the quill will write with the walnut ink—remember, it doesn't have to be perfect.

5 Mark the jar of walnut ink with a label and set aside.

6 To assemble the contents of the box, first line the box with crinkle paper. Then, place a small notebook, chalk, quill or pen with nib, labeled bottle of ink, and alphabet cards inside.

7 Using the white pencil, draw the gift recipient's first initial on the painted box top.

8 Tie the box with some ribbon or twine to complete the gift.

Wooden Signs

When you want to display a message that's more permanent and impactful than a paper sign, try writing it on wood. I love using this technique as a highly dignified way to get a point across. You can re-create classic requests such as "Do Not Disturb," "No Smoking," or "Wash Your Hands." Of course, the sign doesn't have be a command. Once you're comfortable writing on wood, you can make loads of things—table numbers, doorknob hangers, signage for a wedding venue. As a special touch, glue a piece of felt to the back of your sign; it will protect the surface and buffer the sound when a door opens or closes.

Note that for this project you won't want to use a brand-new nib, as the wood's rough surface will damage it. I always save my old nibs for projects like this one.

1.

Sandpaper Rag

2.

Chalk Paint

3.

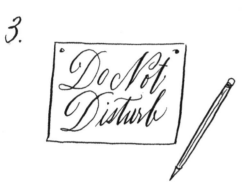

Do Not Disturb

4.

Dr. M White

Do Not Disturb

5. erasers

6.

Low Vok Sealer

7.

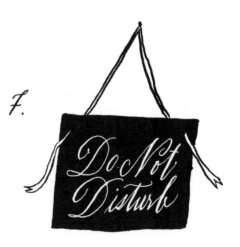

Do Not Disturb

Instructions

MATERIALS

Maple plywood, 5 by 7 inches, ⅛-inch thick, with pre-drilled holes

Sandpaper, 400 grit

Soft cloth

Foam brush

Chalkboard paint and/or assorted craft paints

Pencil

Pointed pen (with old nib)

Dr. Ph. Martin's Pen-White ink

Eraser

Low-VOC acrylic sealer (optional)

Twine or ribbon

NOTE

If your wood doesn't have a pre-drilled hole, attach picture frame–hanging hardware to the back of your sign.

1 Prepare the plywood surface by sanding off any rough edges and lightly sanding the surface so it's as smooth as possible. With the cloth, wipe away any sawdust.

2 Using a disposable foam brush and chalkboard paint, paint both sides and all edges of the plywood. Do at least two coats to get truly opaque coverage. Allow the paint to dry completely.

3 Use a pencil to lightly sketch your letters on the plywood.

4 Using pointed pen and ink, write over your lettered message using the same technique you would on paper. Allow the ink to dry completely.

5 Erase any visible pencil marks.

6 If your sign is going to be outdoors or in a high-traffic area such as the kitchen or bathroom, you may want to paint on one coat of sealer.

7 Thread the twine or ribbon through the sign's holes, tie, and hang.

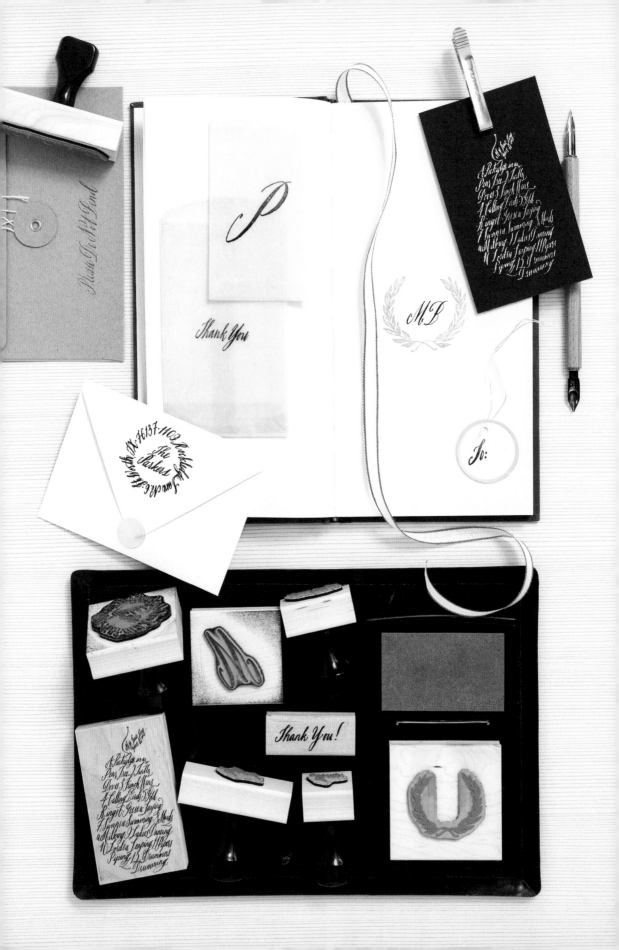

Make Your Mark

Rubber stamps are both beautiful and useful. They have so many applications and are particularly fun for personalizing greeting cards and envelopes. Customizing rubber stamps has become wildly popular and for good reason: it's satisfying to see your calligraphy work elevated beyond the pointed pen. Plus, using a rubber stamp—like the address stamp you'll make in this project, a fantastic gift to a new neighbor or friend who has recently moved—boosts your daily creativity and comes in all sorts of handy, like when you have to send more mail than usual or to make easy and fun holiday greeting cards. And you can easily incorporate color into your correspondence simply by changing the ink-pad color.

The possibilities for custom rubber stamps are endless. I prefer a stamp with a wooden handle as opposed to a self-inking one. Handled stamps have an old-school business stationery aspect to them, and you can use any ink color. With self-inking ones, you are limited to blue or black ink. But it's all a matter of personal preference. And remember: much in the same way that postmarks are made at the post office, the marks made by rubber stamps are not meant to be perfect.

When giving a rubber stamp as a gift that's sure to impress, you could include a colorful ink pad and some blank notecards and envelopes. Give one stamp or expand the set into initials or messages such as "Special Delivery," "Fragile," "Handle with Care," or "Do Not Bend."

1.

2.

3.

4.

5.

6.

Variation

The Parkers
23 Main Street
Dallas, TX 75001

Instructions

SKILL LEVEL

EASY

MATERIALS

Borden & Riley #234
Paris Paper for Pens
(bleedproof)

Round address stamp
guide, copied (see
page 209)

Pencil

Pointed pen

Ink

Eraser

Computer

NOTE

Allow a few weeks for the
stamp production

1 On your paper, trace the circular template shape from the
templates section with a pencil.

2 With the pencil, lightly write the address around the
circumference of the circle.

3 Write the recipient's name on a straight line inside the circle.

4 Using pointed pen, ink your artwork starting with the outer
circle first. Allow the ink to dry completely, then write the text
on the inside. Allow the ink to dry completely.

5 Erase any visible pencil marks.

6 Choose a stamp maker, such as rubberstamps.net online, and
request your stamp be mounted with a wooden handle. You can
specify the desired size of your final stamp if you want to make
it smaller or larger than what you have created; ask to see a
proof before the stamp is made if you are unsure. If your stamp
is to be used with a particular envelope style, measure the
envelope's back flap before ordering the stamp, to make sure
the stamped address will fit.

VARIATIONS

- If you prefer not to have a round stamp, you can make a
 rectangular stamp with the address stacked in three or four
 lines. To do this, draw the lines using a pencil, and write the
 address in pencil first. Most likely this size will need to be
 slightly reduced in order to fit on the back of an envelope flap
 or upper left-hand corner of an envelope.

- Try making initials, illustrations, or doodles into rubber stamps.

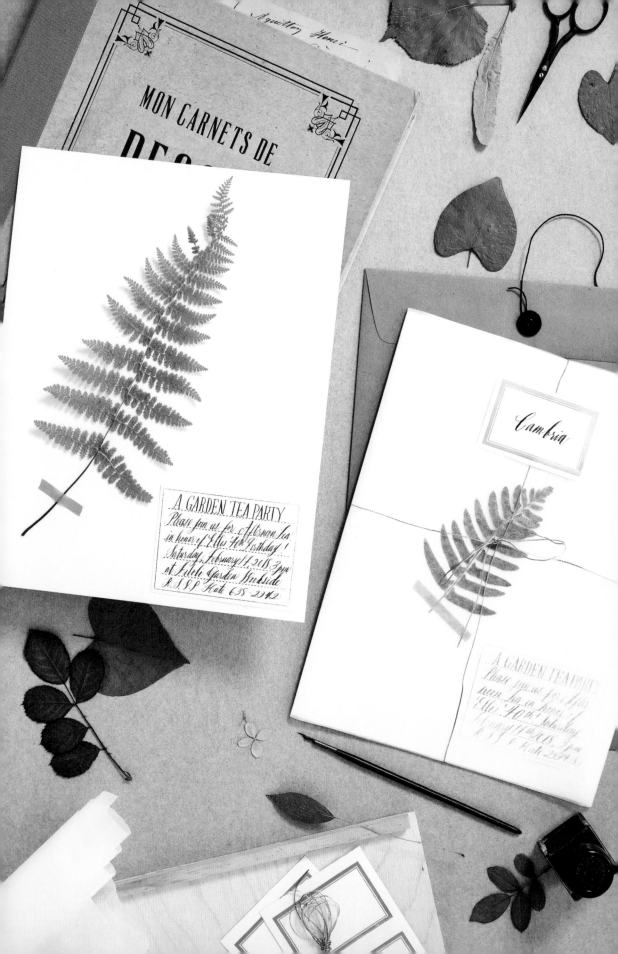

MON CARNETS DE

DE

Cambria

A GARDEN TEA PARTY
Please join us for Afternoon Tea
in honor of Ellie's 4th Birthday!
Saturday, February 14, 2018, 3pm
at Lilah's Garden Creekside
R.S.V.P. Kate 658-2742

A GARDEN TEA PARTY
Please join us for
noon Tea in honor of
Ellie's 4th Birthday
January 14, 2018, 3pm
R.S.V.P. Kate 2342 8

Herbarium-Inspired Invitations

An herbarium is a place to keep a collection of dried plants. In the mid-1800s, it was common for young girls to create herbarium books; an excellent example from poet Emily Dickinson is housed at Harvard University's Houghton Library. I find the handwriting in these vintage keepsakes to be as lovely as the plant pressings.

These elegant invitations are particularly appropriate for bridal showers, birthday luncheons, and afternoon tea parties. You could even extend the theme to the event's placecards, menus, or other paper accessories.

You will need a few dried and pressed plants. You can easily make these by placing a plant clipping or flower between two pieces of acid-free paper and then between the pages of a heavy book. They will dry out in a few days. As an alternative, you can find them on Etsy already pressed.

If your text is long and unlikely to fit on the label, consider writing it directly on the page next to your plant pressing, just as you would see in an herbarium. You can mix both roman and script lettering, too.

I created a label by making a rubber stamp from the Dotted Line Label template on page 209. Then I glued the labels next to a plant specimen and wrapped them with glassine for protection. I added the name of each guest on a gold-bordered label giving each one a personalized touch. If I received an invitation like this in the mail, I would definitely consider it frame-worthy!

1.

2.

3.

GARDEN TEA PARTY
Please join us on
Saturday Feb 14
2:00 Afternoon Tea

4.

5.

Kate

Cambria

Kelly

6.

Washi Tape

7.

Peggy

8.

Mrs. Janice Iman
239 Kaaohua
Kaneohe HI

Instructions

SKILL LEVEL

EASY

MATERIALS

Practice paper or sketchbook

Pencil

Photocopier

White paper, 8½ by 11 inches, 80 lb, like Mohawk Superfine Softwhite

Pointed pen

Walnut ink

Dried and pressed plants

Paper, 8½ by 11 inches, 140 lb paper, like Paper Source Luxe Cream

Thin washi tape

Small vintage labels

Glassine paper cut to 8½ by 18 inches

Thin string or gold twine

12 string-tie Desert Storm envelopes, 9 by 12 inches

4-ply matboard

Adhesive labels in different sizes

Stamps

1 On practice paper or in your sketchbook, pencil out a rough sketch of how the event information—name, date, place, time, RSVP request, etc.—will work within the invitation design.

2 Using the label template found on page 209, photocopy the number of labels that you will need, plus a few extras for good measure, on the 80 lb paper. Print the labels at a size that will fit all of your event information.

3 With pointed pen and walnut ink, write the event information on each label. (If you will be creating a large number of labels, consider having the original one printed professionally, then you can glue them next to the pressed plant.)

4 Arrange a dried plant and event information label on a sheet of the 140 lb paper, and affix them to the paper with washi tape. Repeat for each invitation.

5 On the small vintage labels, write the name of each guest. Set aside and allow them to dry completely.

6 Protect the plants by wrapping each invitation in glassine paper and securing it in the back with washi tape.

7 Tie a thin piece of string (I used gold twine) around the invitation like a present, and affix the small vintage label with the handwritten name on the upper portion of the glassine paper, atop the string.

8 Place each invitation in a string-tie envelope, with a stiff 4-ply matboard for protection and support, and either address them directly or use an adhesive label for the send-to and return addresses. If available, choose a botanical-themed postage stamp.

See beauty everywhere

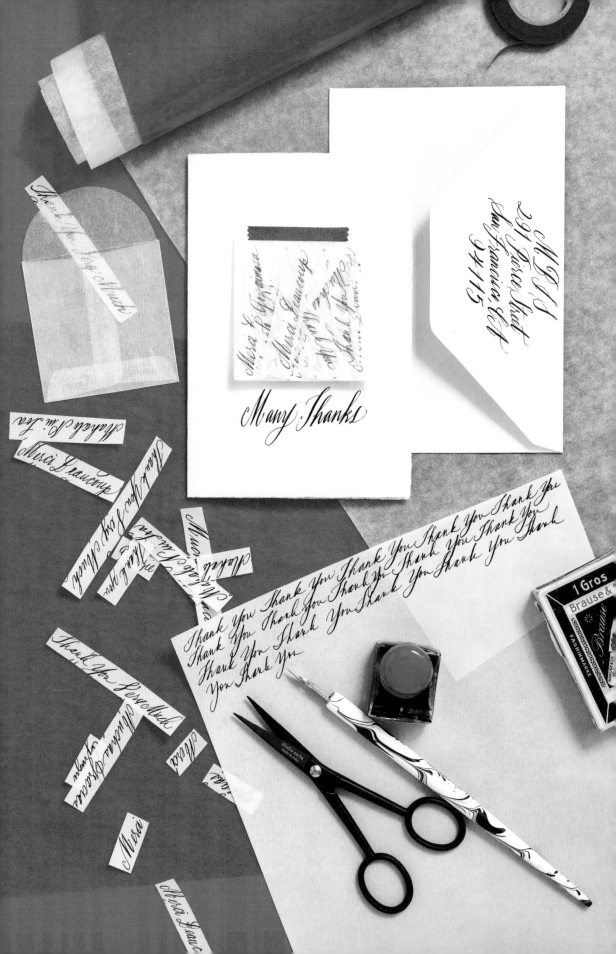

Greetings with Gratitude

Once you have learned the basics of calligraphy, creating a greeting card is quick and easy. Handwritten messages naturally convey a warm, heartfelt message. You can also use your pointed pen on the cover of the card and a regular pen inside to write your message.

A greeting with gratitude allows you to practice connecting letters, and then you get to turn these practice pages (which by no means have to be perfectly calligraphed!) into unique greetings. You'll write *thank you* (or *merci, gracias, arigato, grazie, mahalo* . . . you get the idea) many times, then cut the phrases out and gather them into a small, vellum envelope to give like pieces of gratitude confetti. Many thanks!

1.

2.

3.

4.

THE GIFT OF CALLIGRAPHY

Instructions

SKILL LEVEL

EASY

MATERIALS

Pointed pen

Black ink

Practice paper

Scissors

Vellum or glassine
envelope, 2 by 2 inches

Double-sided tape

Fabriano Medioevalis
folded card, 5¼ by
3⅜ inches

1 Using pointed pen and ink, on practice paper write your gratitude message—such as "Thank you"—about 25 times, each roughly ½-inch tall and 1½ inches long, leaving a little space between each phrase.

2 Cut out each phrase and place as many as you'd like into a vellum envelope.

3 Using double-sided tape, adhere the vellum envelope to the front of the folded card.

4 Using pointed pen and ink, write "Many thanks" or similar message on the card above or below the envelope.

VARIATIONS

I could fill a whole book with ideas for unique greeting cards! See pages 152–153 for some ideas. This is a great place to try out a few of the techniques from chapter 4, especially:

· Write with masking fluid (page 69)

· Experiment with different pens (page 70)

· Try pictorial calligraphy (page 71)

· Use metallic inks (page 68)

· Mix roman lettering with your script (page 72)

· Play with brush lettering (page 74)

· Create botanical lettering (page 204)

Travel often

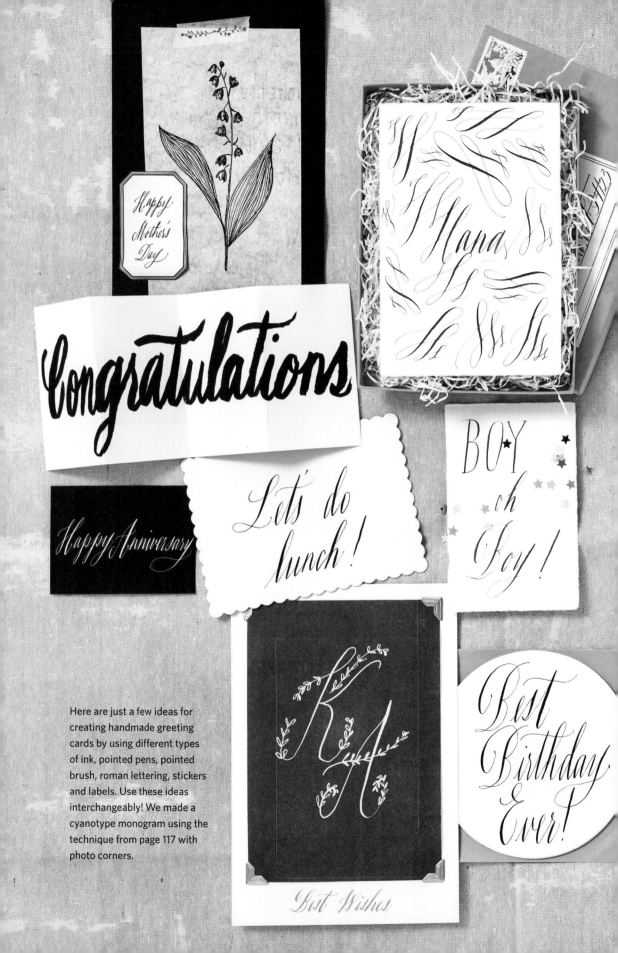

Happy Mother's Day

Hana

Congratulations

Happy Anniversary

Let's do lunch!

BOY oh Boy!

K A

Here are just a few ideas for creating handmade greeting cards by using different types of ink, pointed pens, pointed brush, roman lettering, stickers and labels. Use these ideas interchangeably! We made a cyanotype monogram using the technique from page 117 with photo corners.

Best Birthday Ever!

Best Wishes

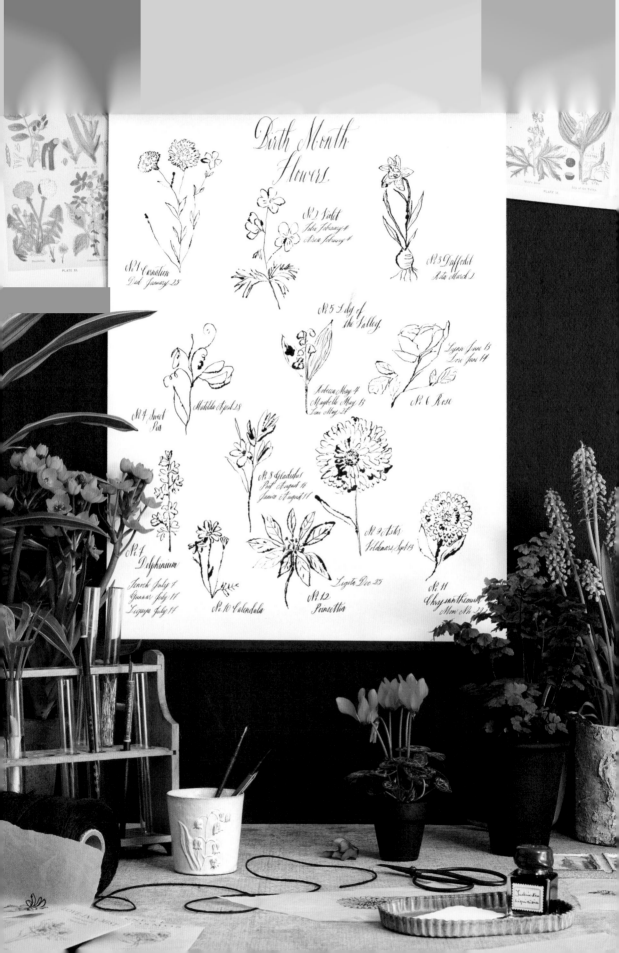

N°. 17

Botanical Poster

My inspiration for this project came from the educational botanical posters that I covet at antique markets and vintage shops. While the posters are often quite large, yours can be any size that you wish. You can display your beautifully illustrated chart in your home or studio as art, or use it as a lovely reminder for special dates and events, such as birthdays and anniversaries of those dear to you.

My approach to drawing flowers is the same as my calligraphy: perfectly imperfect. Keep this in mind as you work through this project. For guidance, I included the flowers that I drew here on pages 205–207 so you can copy them and make them into any size you wish. The drawings are not scientifically accurate, but they suggest some of the flowers' main characteristics. And Andy Warhol's Blotted Line Technique (see page 73) gives your drawings a modern spin on the traditional botanical posters. Remember, this is your creative interpretation!

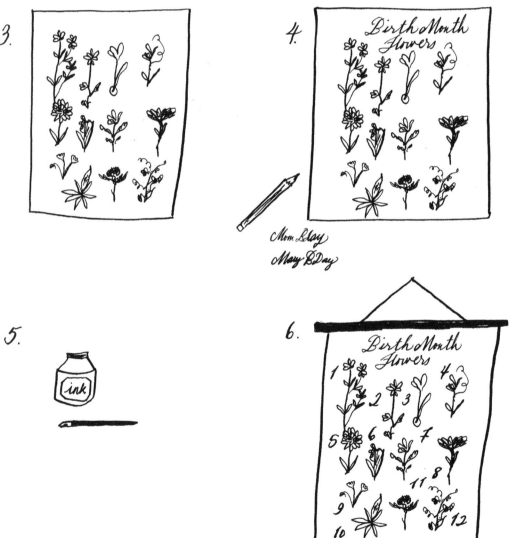

Instructions

MATERIALS

Tracing paper

Pencil

Scissors

Strathmore Drawing paper, 18 by 24 inches

Washi tape

Pointed pen

Black ink

Eraser

Round wood dowels, 20-inch

Glue

String

1 On tracing paper, use a pencil to trace your preferred floral illustrations from pages 205 through 207 or draw your own, leaving a 2-inch border around each illustration. Cut out each illustration, retaining the 2-inch border, and set aside. There should be twelve in total, one for each month. Plan and lay out your design on your drawing paper. Use washi tape to secure your arranged illustrations, you should be able to peal it off later but it is good idea to test the tape to your specific paper.

2 Using pointed pen and ink, ink the traced flowers onto your sheet of drawing paper one at a time using the Blotted Line Technique (page 73). Work from left to right, to avoid smudging the ink.

3 Continue inking until you have all twelve flowers done. Allow the ink to dry completely.

4 Pencil in the information that you want to add, such as the number of each month, important dates, and names. I added "Birth Month Flowers" since I was using my poster to remember birthdays. I also added the name of each flower and a few selected friends' names and birth dates.

5 Finalize the information on your poster in ink. Allow the ink to dry and then erase any visible pencil marks.

6 Display the poster with painted wooden dowels glued to the top and bottom of the poster, then tie some string to the dowels to hang it.

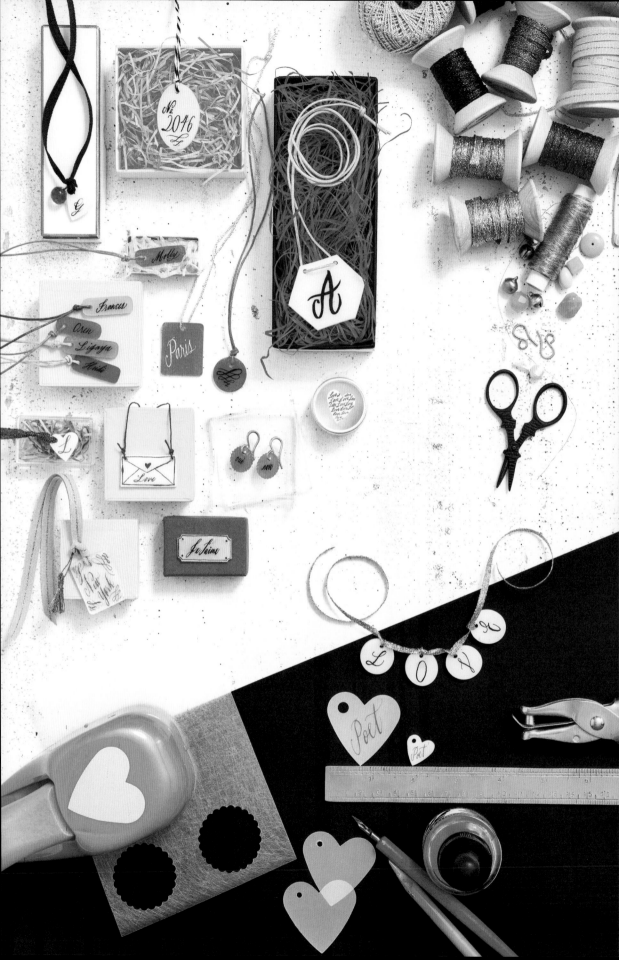

Miniature Charms

Aren't tiny things so charming? I love this project because while it's difficult to actually write very tiny letters, this oven-shrinking process—remember the magical wonder of Shrinky Dinks from your childhood?—lets you shrink down your lettering to a third of its original size. Instant charm!

Creating miniature charms allows you to transform a material from your childhood into a contemporary charm bracelet with a single letter on each charm. You could spell out someone's name, write your children's first names or initials, or write out words such as *Love* or *Friendship*. The photo here shows the charms simply tied onto ribbon and string and hooked onto earring wires, but if you're familiar with jewelry making, you can attach them with metal rings. Once you have this process down pat, you can make virtually anything with these tiny charms. Use different techniques such as brush lettering, and add colors with different pencils or inks. Write single letters, full words, or tiny illustrations, you can create charm necklaces, key chains, tiny Valentines, gift tags, etc. This project is fast and inexpensive, yet oh so charming.

1.

2.

3.

4.

5.

Instructions

SKILL LEVEL

INTERMEDIATE

MATERIALS

Circle punch, 1½-inch

Assorted Shrinky Dinks sheets (Frosted and White)

Pointed pen

Acrylic ink, assorted colors

¼-inch hole punch

String or ribbon

NOTE

When planning your project, keep in mind that the film shrinks to about one-third its original size.

1 Using the circle punch, create four punched-out circles from a sheet of Shrinky Dinks film.

2 Write out your letters with pointed pen and acrylic ink on the face (top) of the film as noted on the Shrinky Dinks package. It's important to use an acrylic-based ink for this process. Allow the ink to dry completely, about 10 minutes.

3 Using the ¼-inch hole punch, punch a smaller hole so that you can tie a string or ribbon through.

4 Follow the instructions on the Shrinky Dinks package to bake and shrink the charms. Allow them to cool completely.

5 Tie the charms onto your string or ribbon.

VARIATIONS

· Attach earring wires (you will need needlenose pliers)

· Color the backside of the film with colored pencils before writing on the face with ink

· Add beads, additional charms, or tassels to personalize

Send a letter just because...

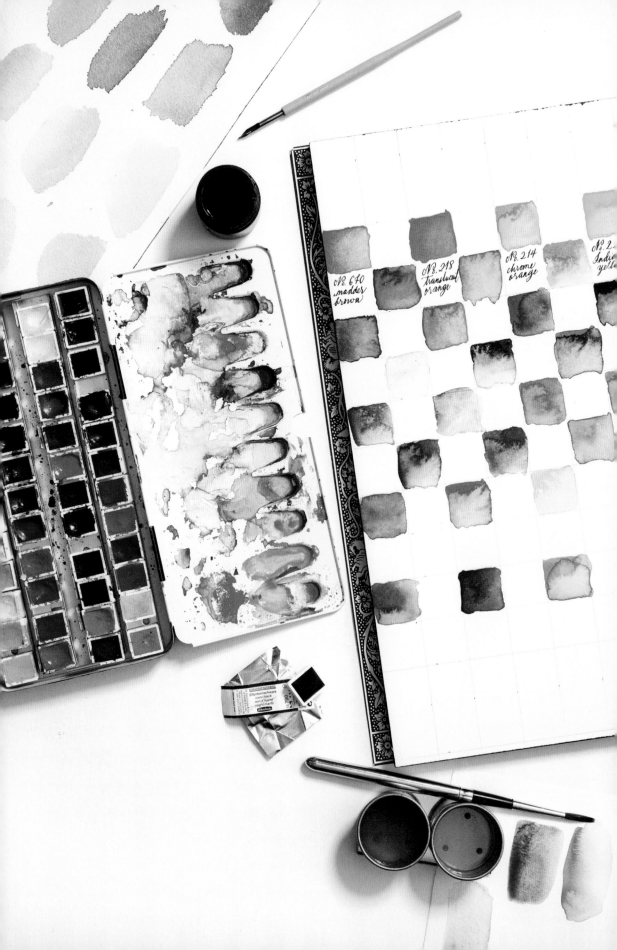

Watercolor Swatches

By creating watercolor swatches, you can incorporate watercolors with your new calligraphy skills. It's especially helpful when you don't know what to paint or are intimidated by painting—simply getting your brush wet with pigment can be meditative and motivating.

In this project, you'll create a color chart of your paints and use calligraphy to label them. You can treat this as a practical color-reference tool for your painting practice, or as a creative project to display or gift as a frame-worthy work of art. You can paint an entire set of watercolors or choose a monochromatic scheme—for example, if a friend's favorite color is pink, create a gift palette using tints and shades of every pink and red paint you have.

I prefer the rough texture of cold press watercolor paper (Arches Aquarelle and Fluid Easy-Block are available in blocks)—hot press paper is too smooth. Keep the paper in the block while you are painting so that it doesn't warp.

No. 254
madder
red dark

No. 352
Magenta

No. 363
scarlet red

No. 353
permanent
carmine

No. 386
deep red

No. 349
cadmium red
light

No. 661
burnt sienna

No. 230
Naples
yellow
red

No. 229
Naples
yellow

No. 893
gold

No. 665
yellow ochre

No. 221
brilliant
yellow dark

No. 528
Prussian
green

No. 519
phtalo
green

No. 509
cobalt
turquoise

No. 475
helio
turquoise

No. 481
cerulean blue
tone

No. 484
phtalo blue

No. 485
indigo

No. 787
payne's grey
bluish

No. 782
neutral
tint

No. 894
silver

No. 101
titanium
white

No. 102
perm.
Chinese White

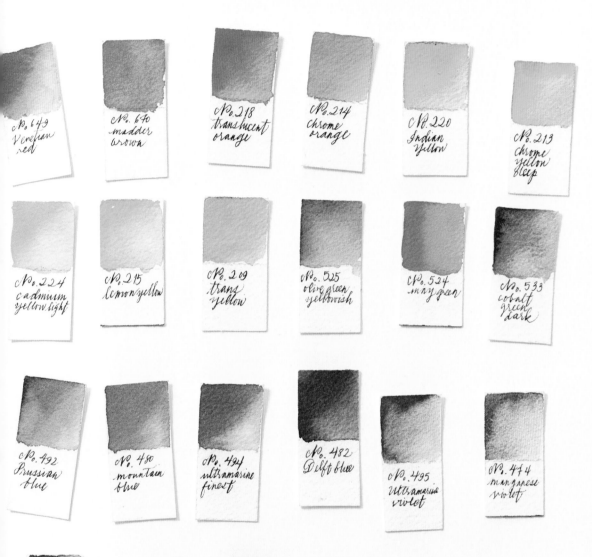

№. 649
Venetian
red

№. 670
madder
brown

№. 218
translucent
orange

№. 214
chrome
orange

№. 220
Indian
Yellow

№. 213
chrome
yellow
deep

№. 224
cadmium
yellow light

№. 215
lemon yellow

№. 209
trans
yellow

№. 525
olive green
yellowish

№. 524
may green

№. 533
cobalt
green
dark

№. 492
Prussian
blue

№. 480
mountain
blue

№. 494
ultramarine
finest

№. 482
Delft blue

№. 495
ultramarine
violet

№. 474
manganese
violet

№. 663
sepia brown

№. 668
burnt umber

№. 780
ivory black

Color swatches that I made
from my Schmicke Watercolor
Paint set.

1.

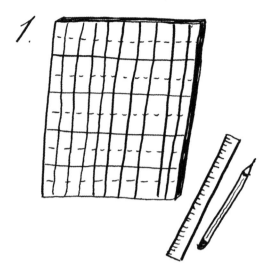

2.

3.

4.

5.

Nº 263
Titanium

Titanium White

ink

6.

Instructions

SKILL LEVEL

INTERMEDIATE

MATERIALS

Pencil

Ruler

Cold press watercolor paper, 10 by 15 inches, 140 lb.

Round watercolor brush, size 4

Watercolor paints

2 containers of water

Cloth or paper towel

Mapping pen

Sumi ink

X-Acto knife or rotary paper trimmer

Cutting mat

1 Using a pencil and ruler, lightly cover your watercolor paper with 1 by 2-inch rectangles. Next, draw a bisecting line on each rectangle. These will be the guide lines for painting your swatches: the top portion will be for painting, the bottom will be for the paint color information. Note that you will checkerboard your swatches, as shown in the photo on page 162, so that neighboring paint colors don't blend together.

2 Dip your brush into clean water and wet the first color, absorbing a lot of pigment into your brush. Paint just the top-left corner of the first rectangle. Working a bit quickly so the paint doesn't dry, dip the brush into the second container of water (designated for brush cleaning), wipe gently on a cloth or paper towel, and then back into the clean water.

3 Wet the bottom-right corner of the square and continue to paint toward the top-left corner. Let the water blend in with the color that you just painted until you achieve a gradient—you should see a slight range in color. Don't aim for perfection here, and if you paint outside the lines, that's okay, you'll trim these later.

4 Move to the next color, skipping a space in between. Continue with all of your colors, working on the top row first and then working your way down alternating the starting point for each row to offset your color grid as shown. This will allow your work to dry without getting smudged.

5 With mapping pen and black ink, write the name of each painted color in the square space beneath it. I like to write the color number too, like "No. 152," which is helpful in case you need to buy another—and it looks beautiful. Allow the ink to dry completely.

6 Cut out the rectangles. Keep in mind that the paper is very thick. If you are not comfortable using an X-Acto knife, ruler, and cutting mat, use a paper cutter or, as a last resort, very sharp scissors. If desired, glue the swatches onto a large sheet of paper and frame it or tape them into your sketchbook as I have done.

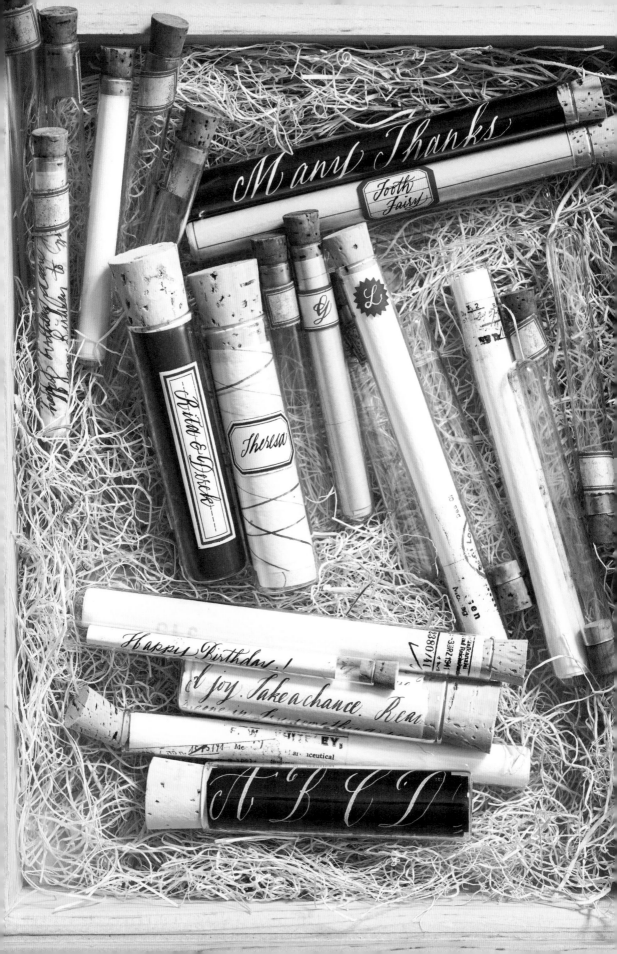

Message in a Bottle

I love making these bottled messages because the glass-vial packaging becomes such a lovely keepsake and displayable art object. I've used this approach for love letters, thank-you notes, poetry, letters from the tooth fairy, bridal shower favors, and party invitations. You can roll your message to face in or out inside the vial. You could even put other materials inside, such as tea leaves, confetti, dried herbs or flowers, or bath salts. Find the glass vials with cork stoppers at antique markets, eBay, Etsy, or scientific suppliers online.

If you plan to mail this project, package it in a box, nestled in shredded paper or wood shavings. Or combine this project with the Wooden Parcel Mail Art (page 113) and double the recipient's pleasure.

1.

2.

3.

Happy Birthday to you Happy Birthday to you Happy Birthday Happy Birthday

ink

4.

Happy Birthday to you Happy

5.

Tooth Fairy

Best Wishes ♥

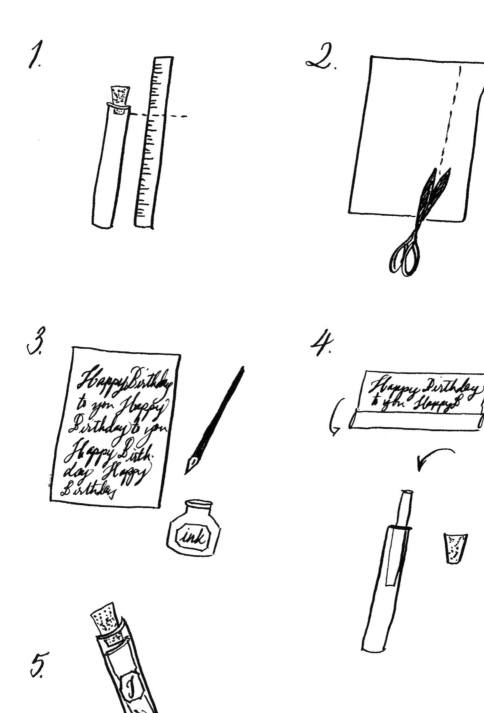

Instructions

SKILL LEVEL

EASY

MATERIALS

Glass vial with cork stopper

Ruler

Text-weight paper

Scissors

Pointed pen

Black ink

Adhesive label

1 With the cork stopper in the vial, measure from the bottom of the vial to the bottom of the cork. This will determine the height of your paper.

2 Trim the paper to that width and any length you desire—you'll roll up the message, so the length is less crucial for ensuring a good fit.

3 Using pointed pen and ink, write your message on the trimmed paper. Allow the ink to dry completely.

4 Consider what part of your message you want to show through the glass, if desired. Roll the paper, place it in the vial, and insert the stopper.

5 Using the pointed pen and ink, write the recipient's name or initial on an adhesive label. Allow the ink to dry completely, and then put the label on the vial.

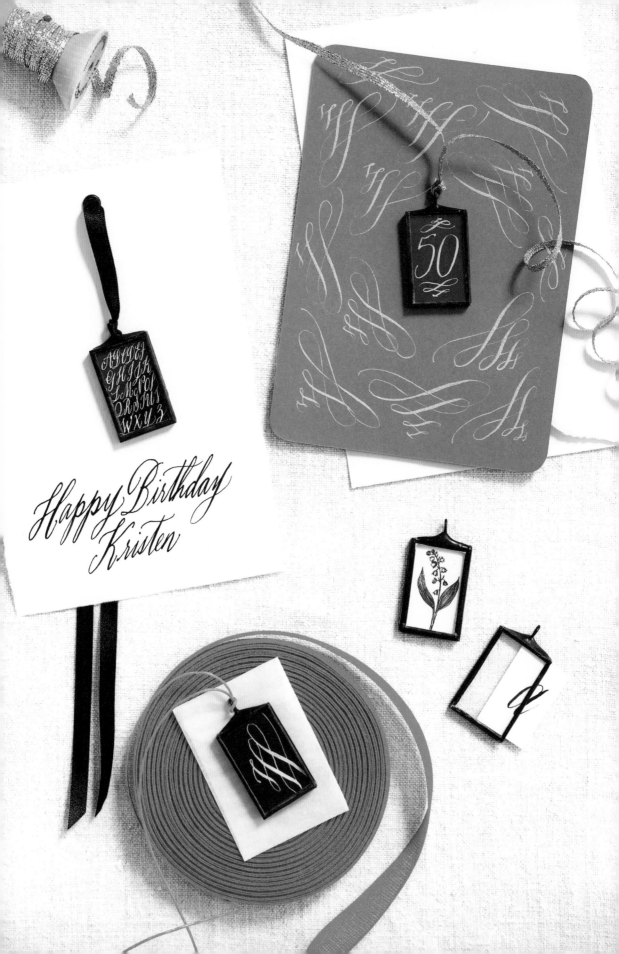

Happy Birthday
Kristen

N^{o.}21

Miniature Keepsake Frames

Turn your calligraphy into a mini work of art and a lovely, intimate gift by housing it in a tiny frame. These pieces can be used as ornaments, gift tags, placecards at a wedding or dinner party, or even worn as necklaces. I have created these keepsake frames with tiny alphabets, specific numbers to celebrate milestones, little botanical illustrations, and mini love letters. Here are some more ideas for your keepsake frame: anniversary number (Golden 50th), Valentine's Day message, birthday number (Sweet 16), short quote, or special words of encouragement (Create, Be, Hope, Love).

Miniature frames are easy to find on Etsy or at your local craft store. The handmade frames in the facing photo have two pieces of glass, offering potential to create artwork in the front and back. In my experience working with small frames, there will be a little bit of trial and error, especially if your frames are handmade. If your frame includes a piece of paper, use this as a template to trace onto your final paper. Because the writing area may be really small, the Nikko G nib is fine for writing initials and numbers. If you are creating something with more text, such as an alphabet or love letter, use a mapping pen. Use white ink on darker paper and black ink for cream-colored paper—metallic inks can also have a beautiful effect.

1.

2.

3.

4.

5.

Ribbon

6.

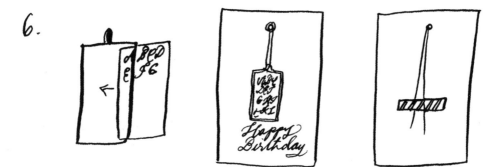

Instructions

SKILL LEVEL

EASY

MATERIALS

Pencil

1 miniature frame with hook, 1 by ½ inch

Black text-weight paper, 8½ by 11 inches

Pointed pen

Mapping pen (optional)

Dr. Ph. Martin's Bleedproof White or Copper Plate Gold (11R) ink

Grommet tool or hole puncher

Fabriano Medioevalis note card, 2½ by 3¾ inches

Antique brass grommet, ³⁄₁₆ inch (optional)

Black ink

¼-inch-wide ribbon

Scissors

Eraser

Washi tape

1 Using a pencil, trace the frame onto black paper.

2 With pointed pen and white ink create your artwork within the pencil lines. Leave a little bit of room for trimming artwork to final size. Set aside and allow the ink to dry completely.

3 With a grommet tool or a hole puncher, punch a hole in the center of the notecard about 1 inch away from the top. If you opt to use a grommet (unnecessary if you used a hole puncher), insert the grommet into the hole and use the grommet tool to press the grommet into place.

4 With pen and black ink, write your greeting on the bottom portion of the card. Allow the ink to dry completely.

5 Determine the length of the ribbon. If you intend for the keepsake frame to be used as an ornament, cut the ribbon to 8 inches; for a necklace, make the ribbon between 24 and 30 inches long. If you are not sure, you can start with a longer piece—it can always be trimmed later.

6 Trim the artwork as necessary and insert into the frame. String the ribbon through the loop on the frame and knot it so that the frame does not slide around on the ribbon. Thread the ribbon that is attached to the frame through the hole on the notecard, and tape any excess ribbon on the back with a piece of washi tape.

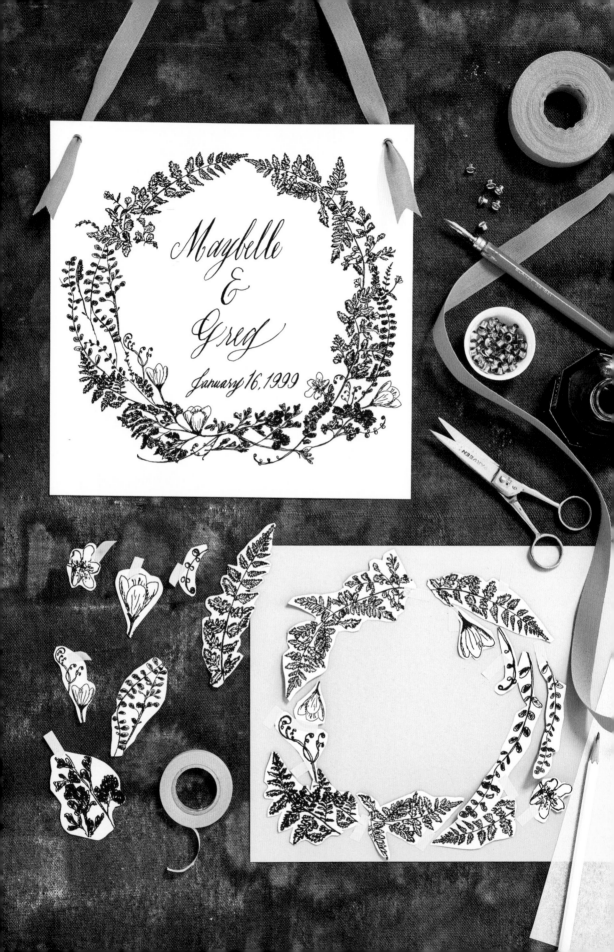

No. 22

Botanical Wreath Illustration

To develop designs for this project, start keeping a sketchbook designated for nature-inspired ideas. Don't worry if you don't know how to draw. You may not realize this but you have been "drawing" letters all along with your calligraphy practice! Simply note any unusual plants and floral elements that you observe in your everyday life. You don't need to go to a botanical garden or museum—there is much to discover in your own backyard or around the neighborhood. I collect old French botany books, Diderot encyclopedias, books on naturalists like John Muir, and engravings such as those from the Linnaeus system, some of which date back to the seventeenth and eighteenth centuries. I love the handwritten information—Latin names, characteristics, and so on—in beautiful lettering.

Once I have an idea of which plants and flowers I want to include in my botanical wreath project, my process starts with a traditional cut and paste—with actual scissors and tape, not a keyboard. This tactile creative process is what we learned in design school, when computer programs like Photoshop and Illustrator were just being introduced. If you have never worked this way, you may find this to be a refreshing exercise and another way to step away from the computer.

Before you begin working, surround yourself with beauty, natural light, and some fresh flowers. This always makes me feel so happy and inspired. And don't be afraid to mix some of the fresh flowers in with your cut-and-paste process. Work with your favorite pair of scissors and colorful washi tape. Working this way allows more freedom, a break from the computer, and a new energy and positive flow. Enjoy the process and don't be afraid of making a beautiful mess!

1.

2.

3.

4.

5.

6.

Instructions

SKILL LEVEL

INTERMEDIATE

MATERIALS

Sketches of flowers and plants

Botanical Wreath templates (page 203); optional

Scissors

Removable Scotch tape

Borden & Riley #234 Paris Paper for Pens (bleedproof)

Light table

Pencil

Pointed pen

Black ink

Eraser

Grommets; optional

Ribbon; optional

1 Decide the type of flowers and plants that you want to include in your illustration. For this wreath I envisioned mostly ferns and a few flowers such as dogwood and ranunculus. Then bring your sketches, books, and any other inspiration to a copy shop or use a multifunction printer at home. Photocopy the images you want to use in your illustration or use the templates on page 203.

2 Choose the copies of the plants that you want to use for the final design. Don't worry about the size, shape, or look of the final illustration; just pick the plants you like, and then cut them out. If you are unsure if you like one enough, cut it out anyway—you may or may not end up using it.

3 Securely tape the cutout images in a wreath shape on bleedproof paper. Play around with a few designs until you are happy with the results.

4 Using a light table and pencil, trace the taped-down composition onto a new sheet of drawing paper.

5 With pointed pen and ink, draw in the lines. Work slowly in small sections, ensuring that you don't smudge the artwork. Allow the ink to dry completely.

6 Erase any visible pencil marks, and then add calligraphy in the center of the wreath. Add grommets and some ribbon for hanging, if desired.

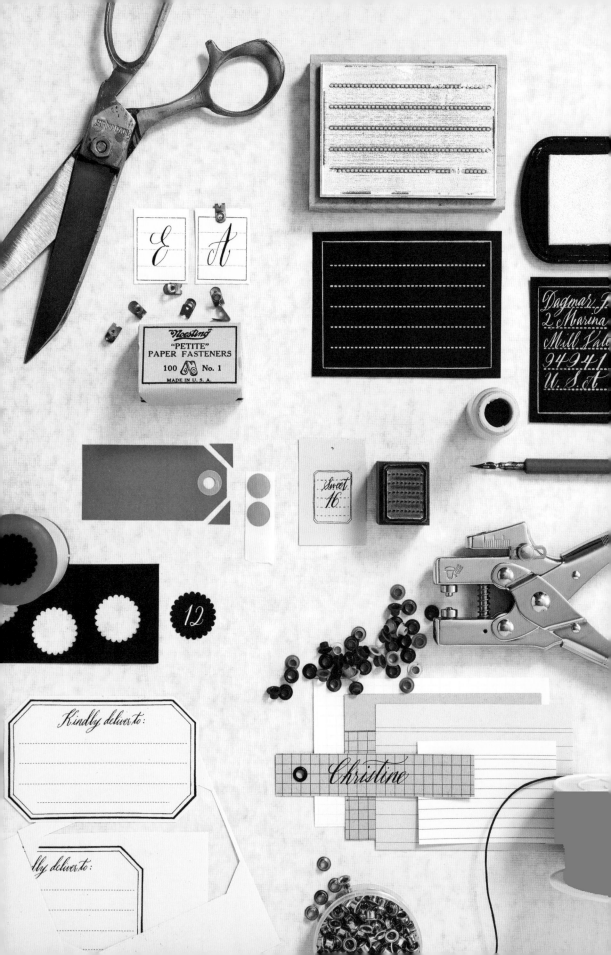

Labels & Tags

Personalized handwritten labels and gift tags are special, beautiful, and worth keeping and displaying. I am always thrilled when I find unused vintage tags and labels at antique markets or thrift stores. Sometimes the papers have aged and developed a natural patina—they are so charming I almost don't want to use them. And the downside is that once vintage pieces are gone, they are nearly impossible to find again, so I try to keep at least one of each in my collection to reference.

Re-creating these special finds for your own work will set your style apart, and you'll have unique formats that differ from what's readily available at your local craft store. There are so many ideas for ways to use them, from parties to wedding favors to gifts. I have even made a luggage tag–inspired invitation.

On pages 184–85 are examples of labels and tags from my personal collection, and examples of my work that they inspired. To create these, in addition to the usual calligraphy-related supplies, I like to keep the following items on hand: assorted colored card stock, chipboard, index cards, watercolor paper, assorted stickers and adhesive paper, rubber stamps, a corner rounder, assorted craft punches, scalloped scissors, ribbons, and string.

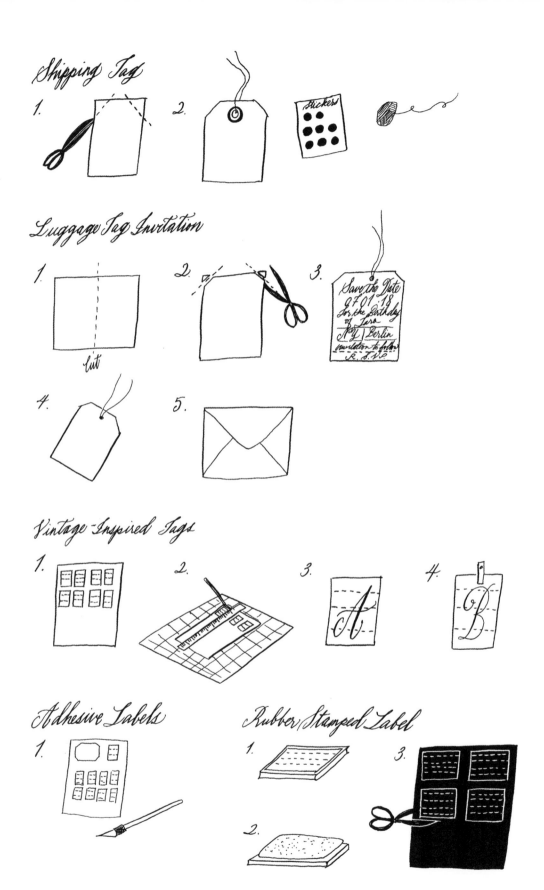

Shipping Tag

1.

2.

stickers

Luggage Tag Invitation

1.

Cut

2.

3.

Save the Date
27.01.18
for the birthday
of Lara
N.Y. / Berlin
invitation to follow
R.S.V.P.

4.

5.

Vintage-Inspired Tags

1.

2.

3.

4.

Adhesive Labels

1.

Rubber Stamped Label

1.

2.

3.

Instructions

MATERIALS

Scissors

Card stock, various colors

Small circular sticker

Hole puncher

String

Pointed pen

Assorted inks

Grommet tool

Grommets

A9 envelope

Photocopier

X-Acto knife

Ruler

Cutting mat

Craft brad or paper fastener

White ink pad

Adhesive-backed paper

Shipping Tag

1 Cut a piece of colored card stock into a rectangular shape. Snip off two of the corners from a short edge at a diagonal angle to emulate the shape of a vintage shipping tag.

2 Place a circular sticker midway between the cut corners, punch a hole through the sticker, and tie some string through the hole.

Luggage Tag Invitation

1 Cut a piece of 8½ by 11-inch card stock widthwise.

2 Snip off two of the corners from a short edge to emulate the shape of a vintage luggage tag.

3 Write on the card with pointed pen and ink that contrasts well with the paper color. Allow the ink to dry completely.

4 Add a grommet to one end of the card and tie string through it.

5 Place into an A9-size envelope.

Vintage-Inspired Tags

1 Photocopy tag template on page 208 onto cream-colored card stock.

2 Using an X-Acto knife, ruler, and cutting mat for a straight, smooth edge, cut out the tags along the outer lines.

3 Write a letter on each card. Allow the ink to dry completely.

4 Use a mini craft brad or paper fastener at the top to give it a vintage feel.

Adhesive Labels

1 Use the templates on page 208 or create your own label. Adding custom calligraphy, photocopy onto adhesive-backed paper and trim with scissors or an X-Acto knife.

Rubber Stamped Label

1 Make the dotted line label found on page 209 into a stamp (see Stamps & Embossers, page 210).

2 Stamp the image with white ink onto black paper.

3 Trim with scissors.

Partie de Colis

EOS 'ON

IF IMPOSSIBLE TO DELIVER NOTIFY SENDER PROMPTLY
FROM
VIA U.S. PARCEL POST
FOR
PLEASE HANDLE CAREFULLY

Take Heart ♥

488
TAIN THIS CHECK
488
AVERY DENNISON, U.S.A.

N°.
2

N°. 4

BEAL-TAISSIER
Job

one
two *three*

M

Pictured on this page are some of
my favorite vintage labels and tags.
On the opposite page are tags and
labels I made inspired by these
collections along with a vintage
tag-inspired save the date.

A B C

For you

I Love You

Kindly deliver to:

Wish list
No.1 Yamaha U1 (Satin Ebony)
No.2 Bellocq Tea No.35 The Earl Grey
No.3 Best Made Co. Sliding Match Safe (Black)
No.4 Concrete Sink for the Studio
No.5
No.6

Please
The D

4 2 3

Hazel

Felix

Aria

Joy
Love Merry
Bright Love a
Merry and
You Truly

Thank You
I Love You
merci
Je t'aime
Congrats

Aster Amaryllis
Bellflower
Begonia Campanula
Buttercup
Daisy Delphinium
Gerbera Her
the Valley Lo
Nemophila
Phlox

Astrid

BON VOYAGE GUTE REISE
Please Save the Date
07 · 01 · 18
DATE
Sunday, July 1, 2018
NAME
Tara K. Reddi
FROM TO
New York Berlin
Celebrate Tara's Birthday with
cocktails and dinner in New York
and wish her Bon Voyage / Gute Reise
before embarking on her new adventure!
- - - - - - - - - - - - - - - - - - - -
{INVITATION TO FOLLOW}

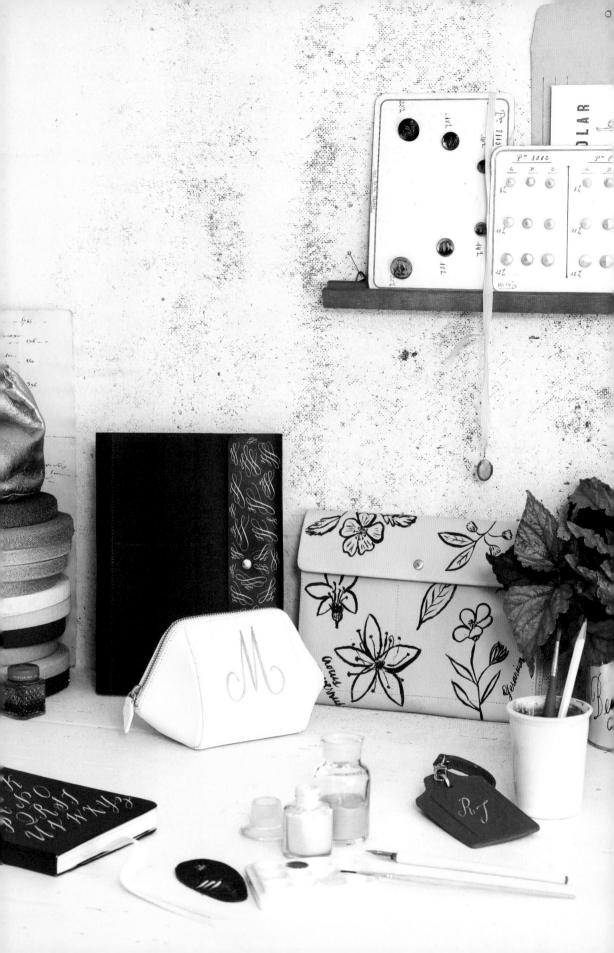

Nº 24

Chic Leather

Here's a way to transform something plain into a chic, one-of-a-kind statement piece that expresses your individuality. Applying calligraphy onto leather is a simple process that yields an extraordinary result—a distinctive and personalized accessory and a perfect gift.

This technique permanently alters leather, so before you attempt to personalize something irreplaceable, expensive, or beloved, practice writing on leather scraps from the craft store or something made of leather you have on hand that's not too precious. For best results, choose leather goods with a smooth surface, not pebbled or textured. These instructions use a nib, but if you love working with a brush, you could do that instead—in fact, if your leather has any texture to it, a brush will work really well for you. You may find paints that are designed for leather at a craft store, however they may be too thick to flow through your nib. I found that using Dr. Ph. Martin's Iridescent Calligraphy Colors straight from the bottle lent the most professional look to the finished piece and they are waterproof. As for coming up with a design, revert to your warm-up strokes (see page 34). These may get your creative juices flowing, or simply repeat one of the warm-up motifs, like figure eights, to create a pattern like the one on this leather clutch. Of course monograms or lettering are always good options, too.

1.

2.

3.

Test

4.

Instructions

SKILL LEVEL

ADVANCED

MATERIALS

Dr. Ph. Martin's Copper Plate Gold (11R) ink

Small round brush, size 2 or 4

Pointed pen

Leather scraps

Leather clutch or other accessory

Paper towel

Water

1 With the lid still on the bottle be sure to shake the Copper Plate Gold well. The ink tends to separate so you will need to stir it with a brush often while using it.

2 With a small brush, paint this mixture onto your nib (instead of dipping your nib directly into the paint, which can clog your nib), and make some practice marks on the leather scraps.

3 Once you feel comfortable writing on leather, draw your design onto your final piece. Just go for it! Even if the final result isn't "perfect" or exactly what you expected, don't be hard on yourself—you've just created a totally custom work of art.

4 If you make a "mistake" on the final piece it can be cleaned with a paper towel moistened with a little bit of water, but it has to be done before the ink dries. Let your piece dry for 24 hours before using it.

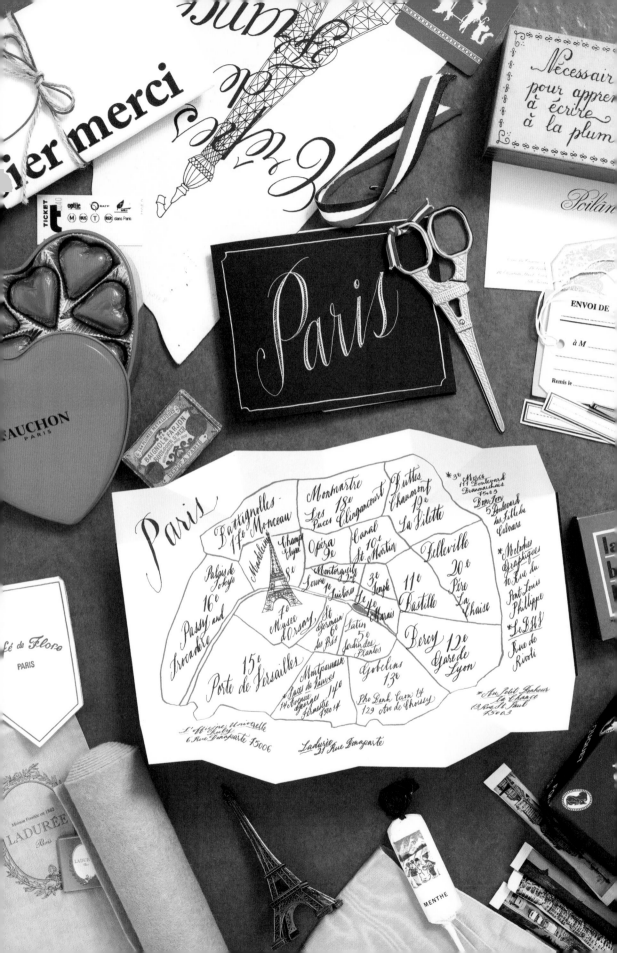

Folded Map Souvenir

The inspiration for this project came from a map that a hotel concierge in Shanghai gave me. It was a small, folded walking map that popped open when you unfolded it, then folded back down neatly. I was so charmed by the simple mechanics of the map that I took it apart immediately and obsessively taught myself how to re-create it.

To make this souvenir, you'll draw an original map, photocopy it, fold it, and adhere it to a decorative cover, like a greeting card. Don't worry about being geographically accurate—this is more of an artistic interpretation of a place than an actual map. Once you have the technique down, you can create your own version of this map for any event, like birthday parties and weddings. I made the one shown here as a special souvenir for my best friend after she and I spent a week in Paris celebrating my fortieth birthday.

1.

2.

3.

4.

5.

6.

7. a. Fold

b. Fold & open

c. Fold

d. Fold

e.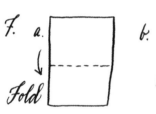
1 2 3
4 5 6

f.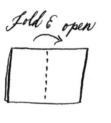

8. card stock Fold
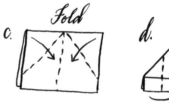

9.
Paris

10.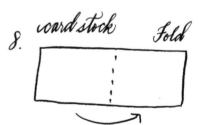

Instructions

MATERIALS

Computer and printer

Printer paper, 8½ by
11 inches

Light table

Strathmore Drawing paper,
8½ by 11 inches

Tape

Pencil

Pointed pen

Ink

Eraser

Photocopier

Text-weight paper

Bone folder

Card stock cut to
4¼ by 11 inches

Double-sided tape

1 Find a map online. Print it in landscape orientation. This will act as a rough guide of where to place things on your map.

2 Place the printed map on a light table and lay your drawing paper on top. Tape the pieces of paper together to keep them aligned.

3 Using a pencil, lightly trace the overall shape of the place. Add in any other lines, illustrations, and lettering that you want to include in your map. For example, for Paris I traced the boundary of the city, then the shape of each arrondissement, and then I wrote the names of special places I wanted to feature.

4 When your sketch is final, ink over the pencil lines with a pointed pen. Allow the ink to dry completely.

5 Erase any visible pencil lines.

6 Photocopy your map onto text-weight paper.

7 With your drawing face up, follow the illustrated steps to fold your map so that it pops open and closes smoothly. You are making origami folds, and the pop-up function will work best if you make clean, neat creases with a bone folder. Steps: **a.** Fold in half widthwise, leave folded. **b.** Fold in half lengthwise, then unfold this step. **c.** Using the center folded line from step *b* as a guide, with the folded edge from step *a* at the top, fold in the right and left corners squarely making 45 degree folds, toward the center fold line. **d.** Fold each of the short outside edges in half to the center. **e.** Open up completely. Bring points 2 and 5 toward each other and invert their folds. Invert the top section of the foldline at point 1. Repeat this with points 3, 4, and 6. **f.** Gently coax the page to collapse into itself and fold.

8 Fold your card stock in half lengthwise, so it's 4¼ by 5½ inches (to fit an A2 envelope). Use the bone folder to make a clean crease.

9 Using the pointed pen and ink, write a title and any decorations on the front of the card stock. Once the ink is dry, write a personal message on the back.

10 Using double-sided tape and following the illustrated steps, adhere your map to the inside of the card stock cover.

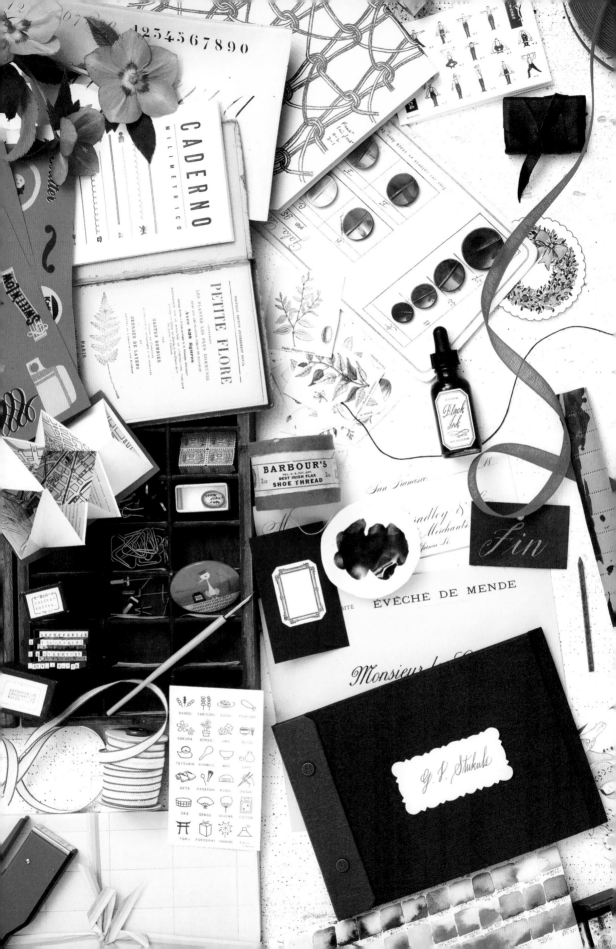

To be inspired is a gift

As you continue to be guided by the gift of calligraphy my hope is that it will open up your creativity to endless possibilities. Remember to surround yourself with people who inspire you, positive thoughts, and things that capture your heart. I have found that this is what makes me most vibrantly myself and makes each day more and more meaningful.

TEMPLATES

Most of the templates shown in this section are reduced in size to accommodate the parameters of this book. They can be copied in a range of sizes to suit your individual requirements and creativity.

Maybelle's Guide Sheet (OPPOSITE)

The guide sheet should be enlarged to fit an 8½ by 11-inch sheet of paper, which is the size that I originally created it. You can copy it directly onto your paper or copy it on to a heavier weight paper to use as a guide underneath translucent materials such as vellum. If you plan to use plain copy paper, practice on a light table to see the lines better. You can also enlarge or reduce it in scale to suit a range of letter sizes and applications.

Warm-up Strokes (PAGE 34)

When you are ready to start with some strokes, gather a stack of paper—roughly ten sheets or so—to create a nice padded surface for your practice. My favorite calligraphic exercises are the compound curve, ovals, and the figure eight.

Compound Curve	Ovals	Figure Eight

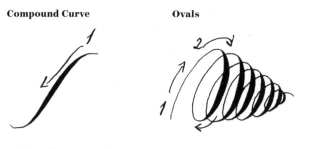

Pointed Pen Script Connecting Letters (PAGE 47)

When connecting letters to form words, giving each letter its own space to breathe, allowing each word to amplify its meaning, is a fine balance. You can achieve this by the way you space your letters or the angle at which you choose to write.

abcdefghijklmnopqrstuvwxyz

May

Pointed Pen Script (PAGES 40-46)

This alphabet is my own hand and evolved over time by practicing several styles of calligraphy such as French Roundhand and Copperplate.

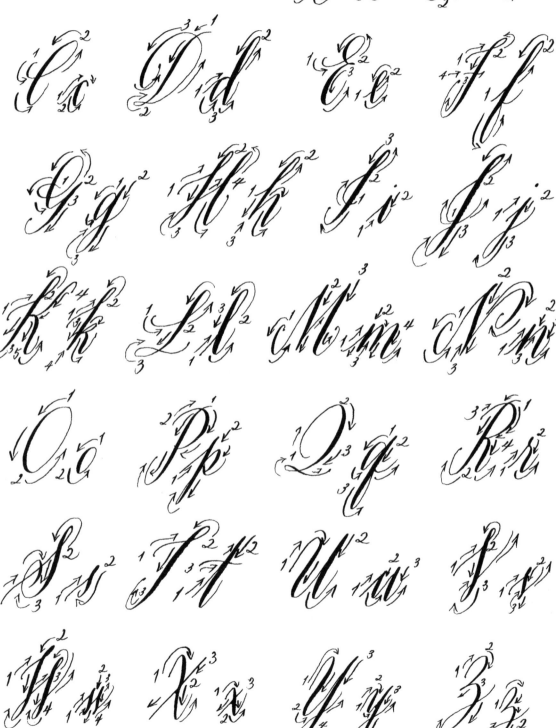

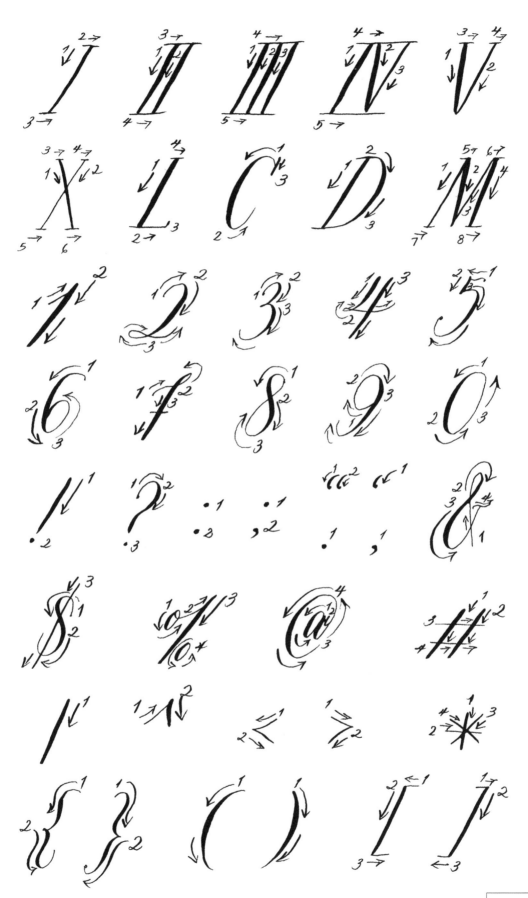

Roman Lettering (PAGE 72)

This alphabet is my interpretation of typography that was originally developed for carving letterforms in stone.

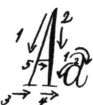
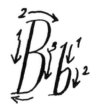

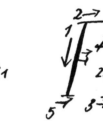

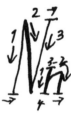
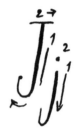

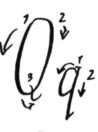

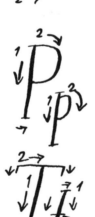

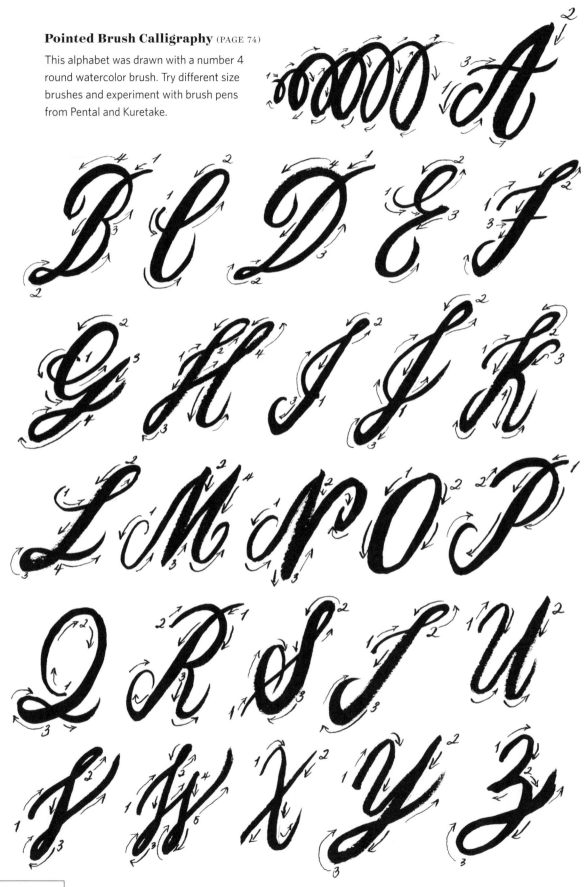

Pointed Brush Calligraphy (PAGE 74)

This alphabet was drawn with a number 4 round watercolor brush. Try different size brushes and experiment with brush pens from Pentel and Kuretake.

a b c d e f g h i j
k l m n o p q r
s t u v w x y z

0 1 2 3 4 5 6 7 8 9

Botanical Wreath Illustration (PAGE 177)

Flowers and leafy stems drawings from my sketchbook. Draw
your own or use these at any size that suits your project.

Botanical Script

(CYANOTYPE ALPHABET, PAGE 117)

This alphabet was inspired by vintage French embroidery samplers from the late 1800s.

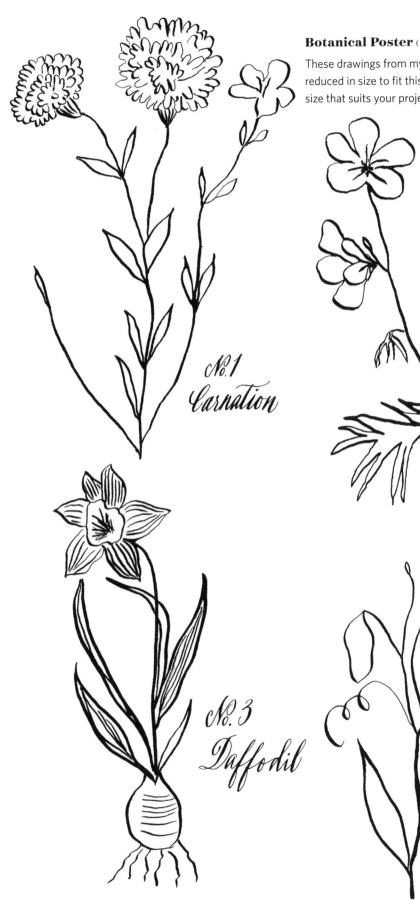

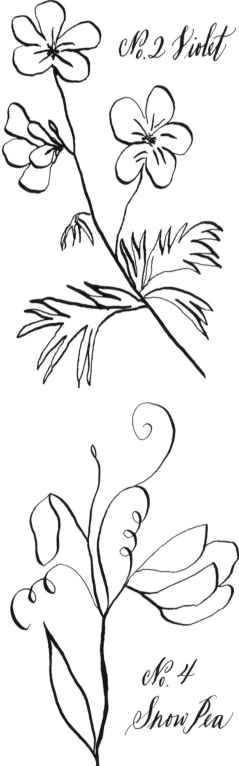

Botanical Poster (PAGE 155)

These drawings from my sketchbook have been reduced in size to fit this book. Copy them in a size that suits your project or draw your own!

№.2 Violet

№.1 Carnation

№.3 Daffodil

№.4 Snow Pea

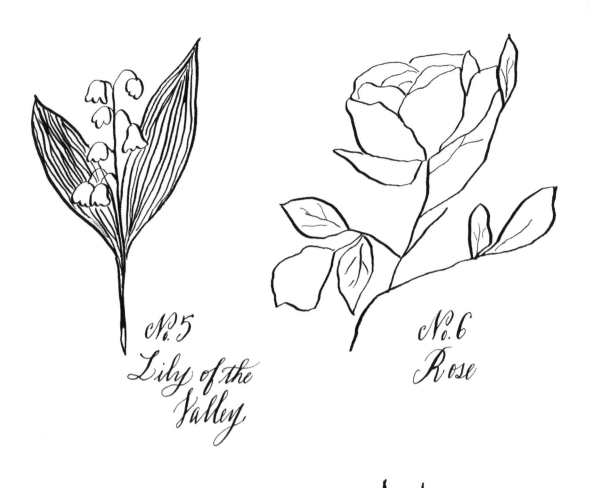

No. 5
Lily of the
Valley

No. 6
Rose

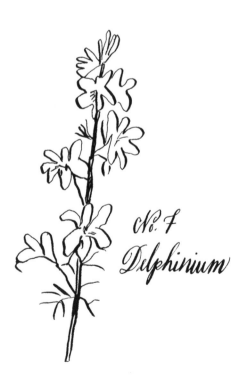

No. 7
Delphinium

No. 8
Gladiolus

No.9 Aster

No.10 Chrysanthemum

No.11 Marigold

No.12 Poinsettia

Labels, Tags & Stamps (PROJECT PAGES 141, 181)

Here are just a few examples from dozens of designs that I have created inspired by vintage labels and tags that I have collected during my travels.

Kindly deliver to:

(PAGES 71, 141, 145, 181)

To:

Thank You

From:

Fragile

Special Delivery

Please Do Not Bend

ROUND ADDRESS
STAMP GUIDE

DOTTED LINE LABEL

SOURCES

Calligraphy Supplies

Pens, Nibs, Ink, Calligraphy books

CASTLE IN THE AIR
castleintheair.biz
+1 510-204-9801

JET PENS
jetpens.com

JOHN NEAL BOOKSELLER
johnnealbooks.com
+1 800-369-9598

PAPER & INK ARTS
paperinkarts.com
+1 800-736-7772

Art Supplies & Stationery

Acrylics, Brushes, Calligraphy supplies, Gouache, Ink, Labels, Paper, Picture framing, Ribbon, Tags

ADDISON ENDPAPERS
addisonendpapers.com
+1 510-316-0100
Vintage ephemera

ARCH DRAFTING AND SUPPLIES
archsupplies.com
+1 415-433-2724
Glassine

ARTIST & CRAFTSMAN
artistcraftsman.com
+1 844-644-7778

BELL'OCCHIO
bellocchio.com
+1 415-864-4048

BLACK INK BOSTON
museumofusefulthings.com
+1 617-497-1221

BLICK ART MATERIALS
dickblick.com
+1 800-828-4548

BOB SLATE STATIONER
bobslatestationer.com
+1 617-547-1230

CASE FOR MAKING
caseformaking.com

CURTIS STEINER
curtissteiner.com
+1 206-297-7116

FLAX
flaxart.com
+1 844-FLAXART

JOANN
joann.com
+1 888-739-4120

MCNALLY JACKSON STORE: GOODS FOR THE STUDY
+1 212-219-2789

MICHAELS
michaels.com
+1 800-642-4235

ONCE AROUND MILL VALLEY
oncearound.com
+1 415-326-5217

POKETO
poketo.com

TAIL OF THE YAK
+1 510-841-9891

TINSEL TRADING
tinseltrading.com
+1 510-570-2149

UTRECHT
utrechtart.com
+1 800-223-9132

WELLER PROJECTS
wellerprojects.etsy.com

Paper & Envelopes

ENVELOPES.COM
envelopes.com
+1 877-683-5673

JAM PAPER
jampaper.com
+1 800-8010-JAM

PAPER PRESENTATION
paperpresentation.com
+1 800-727-3701

PAPER SOURCE
paper-source.com
+1 888-PAPER-11

Stamps & Embossers

FRED LAKE
fredlake.com
+1 866-935-7711
Embossers

MADE TO ORDER STAMP & SEAL
customembossers.com
+1 800-606-9655

RUBBERSTAMPS.NET
rubberstamps.net
+1 877-391-6369

SIMON'S STAMPS
simonstamp.com
+1 800-HE-SIMON

THESTAMPMAKER.COM
thestampmaker.com
+1 888-451-7300

Antiques

Old boxes, labels, botanical posters, glass pens, onionskin paper, vintage copybooks

ALAMEDA POINT ANTIQUES FAIRE
alamedapointantiquesfaire.com
+1 510-522-7500

BRIMFIELD ANTIQUES
brimfieldshow.com

EBAY
ebay.com

ETSY
etsy.com

PARIS HOTEL BOUTIQUE
parishotelboutique.com
+1 415-305-7846

ROSE BOWL FLEA MARKET AND MARKETPLACE
rgcshows.com/RoseBowl.aspx

Bottles, Jars, Vials

AMERICAN SCIENCE & SURPLUS
sciplus.com
+1 888-SCIPLUS

SPECIALTY BOTTLE
specialtybottle.com
+1 206-382-1100

Glass & Ceramic Housewares

CB2
cb2.com
+1 800-606-6252

IKEA
ikea.com

Letterpress, Printing & Design Services

DEPENDABLE LETTERPRESS
dependableletterpress.com
+1 415-503-0981

FEDEX
fedex.com
+1 800-GOFEDEX

MILKFED PRESS
milkfedpress.com
+1 510-703-9427

Leather

HIDE HOUSE
hidehouse.com
+1 800-453-2847

MARK AND GRAHAM
markandgraham.com

International Calligraphy, Stationery, Art Supplies & Antiques

Vintage labels, Calligraphy supplies, Books

AU PETIT BONHEUR LA CHANCE
aupetitbonheurlachance.fr
+33 01-42-74-36-38

LE BHV
bhv.fr
+33 (0)977 401 400

BOESNER
boesner.com
+49 0-23-02 / 910 66 - 13

CALLIGRAPHY SUPPLIES AUSTRALIA
calligraphysuppliesaustralia.com

FLEAING FRANCE
fleaingfrance.com

ITOYA GINZA TOKYO
ito-ya.co.jp

KREMER PIGMENTS
shop.kremerpigments.com
+1 800-995-5501

MANUFACTUM
manufactum.com
+49 2309-939 095

MARCHÉ AUX PUCES DE LA PORTE DE VANVES FLEA MARKET
pucesdevanves.typepad.com

MELODIES GRAPHIQUES
+33 1 42 74 57 68

MILLIGRAM
milligram.com
+61 3 9314 4304

MUJI
muji.com

OEDO FLEA MARKET
antique-market.jp/english
+81 03-6407-6011

THE OLD STUFF SHOP
oldstuffshop.nl
+31 06-44-81-46-83

PIGMENT TOKYO
pigment.tokyo

PRESENT AND CORRECT
presentandcorrect.com
+44 020 7278 2460

SCRIBBLERS
scribblers.co.uk
+44 (0)845 003 7148

SEKAIDO
www.sekaido.co.jp

THE SOCIETY INC
thesocietyinc.com.au
+61 612-9516-5643

TOKYU HANDS
tokyu-hands.co.jp/en

TOOLS TO LIVE BY
toolstoliveby.com.tw/en
+886 2 2732 8777

TRAVELER'S FACTORY
travelers-factory.com

INDEX

With Gratitude

To my husband, Greg, the best gift-giver in the whole world. Gunnar for always diving in feet first (since birth) and Ligaya, my beautiful daydreamer, I am always inspired by your creativity. Thank you for assisting me at my workshops and for putting up with a very tired and busy mommy. I love you all so very much. To Ali Slagle who first approached me with the idea of this dream book. Jenny Wapner and Leigh Saffold, my editors, and the team at Ten Speed/Watson-Guptill. Kate Woodrow of Present Perfect Department for going above and beyond for me. Rebecca, Patrick, and Poet for the constant flow of ideas, espresso, and hot chocolate, without you this would have been an entirely different book.

Marc & Lourdes Bacani, Mom & Dad, Janice Imasa, Rita MacDonald, Derek Voldemars Stukuls, Voldemars & Ligita Stukuls, Lucio Family, Stukuls Family, Chakars Family, Bacani Family, James Butler, Shigeko Yamaguchi Butler, Theresa Canning Zast, Darcy Miller, Jordan Ferney, Lisa Congdon, Kristen Hewitt, Angie Myung, Ted Vadakan, Angela Liguori/Studio Carta, Creativebug, Mark & Graham, Chronicle Books, Dagmar Herbstreuter, Julie Horton, Katie Albayrak, Chloe Warner, Brad Rhodes, Kerensa Hogan, Casie Permenter, Canyon School, Sarah Keller, Kelley Westling, Cambria Blakely, Mary Ellis Arnold, Kate Wees, Phil Hyunh, Megan & Giles Morton, Stephanie Stamatis, Alyce Harley, McLane-Gonzalez Family, Joanna & Andrew Katz, Brigid, Mark & Matilda Malabuyo, Stefan Gustafsson, Christine Hebel, Levi Velvick, JT meister aka John H. Thomas, Tanya Keliihoomalu Flores, Michael Cueva, Caryn Saito, Allyn Bromley, Anne Bush, Alan Shimato, Chae Ho Lee, Carl F. K. Pao, Olivia San Mateo, Elizabeth Messina, Samantha Hahn, Grace Biggs, Dr. Veronica Shim, Jill Lauck, Katrina, Philip & Sophia Nazareth, Letty Semana, Lori Nova Endres, Etienne Fang, Amelia Ho, Tristan La Fer, Michelle Porter, Jess McCarty, Kerry Lucas, Anne Keenan Higgins, Rae Dunn, Theresa Weller, Lauren McIntosh, Emily J. Snyder, Stephanie Fishwick, Janis Anzalone, Sabine Pick, Victoria Heifner, Diva Pyari, Breda Hynes, Ellie & Morgan Mueller, Lisa, Dave & Penelope Grant, Cori Uwaine, Linh Trieu, Jessie James, Heidi Moore-Gill, Julie & Michael Parker, Ingrid Fetell Lee, Meg Mateo, Meg McGinnis, Tara K. Reddi, Mike Wesson, and finally each and every one of the students that I have ever had the privilege to meet and learn from.

"As a former student of Maybelle's, I can attest to her unique and accessible approach to modern calligraphy: there is room for everyone. Whether you are brand new to calligraphy or you've already got some practice under your belt and want to take your work to the next level, *The Gift of Calligraphy* takes you from materials to technical tips, and from understanding traditional styles to experiments for developing your own unique look—all in an easy-to-follow, stunningly beautiful guide you'll want to come back to again and again."

—**LISA CONGDON**, *fine artist, illustrator, and author of* Broad Strokes *and* A Glorious Freedom

"Maybelle is a woman of passion, grace, and talent, but above all, she wants everyone to have access to beautiful hand lettering. She believes that when pen is on paper, it's a meditative gift and the antidote to these modern times. No mark is ever seen as 'imperfect', no stroke is ever overly corrected; it's all about the flow and letting go."

—**MEGAN MORTON**, *stylist and author of* Home Love *and* It's Beautiful Here

"Maybelle has designed every project in this book with care and thoughtfulness, making them accessible and relevant to everyone— from the amateur to the expert calligrapher. In a modern world of electronic messages, Maybelle brings back a tactile craft that is perfect for giving to friends (or keeping for yourself). *The Gift of Calligraphy* is a must-have for every crafter's library."

—**JORDAN FERNEY**, *founder of Oh Happy Day!*